COOPER HENDERSON AND THE OPEN ROAD

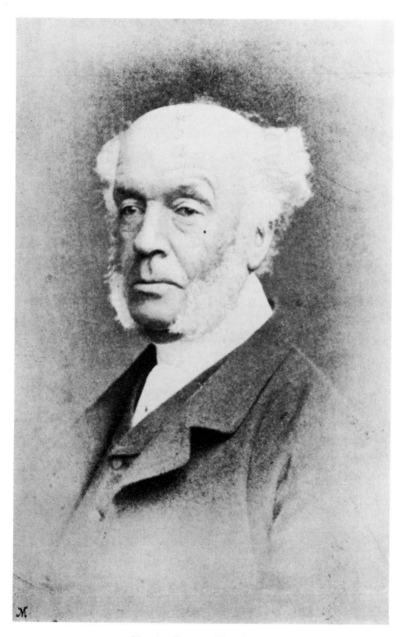

Charles Cooper Henderson
1803–1877

THE LIFE AND WORKS OF
Charles Cooper Henderson
1803–1877

Cooper Henderson
and the
OPEN ROAD

by
CHARLES LANE

J. A. Allen & Co Ltd
LONDON

Published in 1984 by
J. A. Allen & Company Limited
1 Lower Grosvenor Place
London SW1W OEL

British Library Cataloguing in Publication Data
Lane, Charles
Cooper Henderson and the Open Road
1. Henderson Cooper
2. Painters – England – Biography
I. Title
759.2 ND497.H4

ISBN 0-85131-392-2

Designed by Eric Stubberfield
Photoset in Great Britain by
Rowland Phototypesetting Limited, Bury St Edmunds, Suffolk
Printed by St Edmundsbury Press, Bury St Edmunds, Suffolk
and bound by Robert Hartnoll Limited, Bodmin

TO
Celia

Contents

Illustrations

Preface

About twenty years ago, whiling away a half-hour in Sotheby's auction rooms, I spotted a small watercolour of a baggage waggon; the mount was inscribed 'Charles Cooper Henderson 1803–1877'. I bought it and still have it. I quickly made it my business to discover as much as I could about the artist and his work. It was not very long before I realised my original purchase was not by Cooper Henderson, but by then I admired his authentic paintings, watercolours and engravings and from what I had managed to discover about the man I was curious to learn more.

Among a series of articles written for *Baily's Magazine*, Sir Walter Gilbey wrote about Cooper Henderson in September 1895. This piece, with some small changes, was included in Sir Walter's *Animal Painters of England from the year 1650*, published in 1900. In March 1910 three oil paintings and twenty watercolours by Cooper Henderson which had been removed from Cambridge House, Regent's Park where Sir Walter Gilbey had lived were sold by auction. Another enthusiast of Cooper Henderson was the late Hugh McCausland who wrote about him in his two admirable books: *The English Carriage*; and *Old Sporting Characters and Occasions from Sporting and Road History*, both published in 1948.

These sources and the *Dictionary of National Biography* provided the guidelines for further research which, as I progressed, suggested to me that there was room for a monograph on Cooper Henderson, his times and his work. I also felt that while James Pollard (the subject of my friend and author, Mr Bobby Selway's three books: *The Regency Road*; *James Pollard 1792–1867*; and *The Golden Age of Coaching and Sport*) may be acknowledged as the most decorative painter of coaches, Cooper Henderson's claim to be unequalled in depicting the pace, spirit and excitement of travel on the Open Road in the 19th Century should be stated.

This book therefore provides a description of the times and surroundings in which Cooper Henderson was brought up, educated and practised his art, a biography of his life with a commentary on some of his best work and, for comparison, some notes on contemporary painters of coaches and the Road. As well as illustrating a selection of his paintings, watercolours and engravings, there is a list of his pictures which may be seen in various galleries and a record of all the published engravings. From what is written, I hope the reader will be able to judge for himself or herself the place in which Cooper Henderson should stand among sporting artists.

Acknowledgements

I have been gathering material for this book intermittently for more than ten years. During that time I have been helped by a great many people whose assistance I now wish to acknowledge. Because of the passage of time, my fear is that there may be some who feel they have made a contribution but do not find their name here; to them I apologise sincerely.

Some small parts of this book have appeared in a different form in a *British Sporting Art Trust News Letter*, *Country Life* and *Art & Antiques Weekly* (now incorporated in *The Antique Dealer and Collectors' Guide*). I am indebted to the trustees of the BSAT and the editors of the two journals for their permission to use this material.

I have welcomed the encouragement and advice of Dr Robert Fountain, a trustee and presently Chairman of the Executive Committee of the British Sporting Art Trust, of Mr Bobby Selway, Mr Dudley Snelgrove and Mrs Stella Walker. To each of them I owe a particular debt for their generosity in allowing me to share part of their extensive knowledge of sporting art.

In my research of the life of Cooper Henderson the Society of Genealogists set me on the right path and in recent years Mrs A. Boulton has been tireless, using detective work of a high order to establish where Cooper lived in retirement at Halliford-on-Thames. Mr Terry Kay has also been most helpful as have the staffs of the Guildhall Library, London Library, the Museum of London and a number of provincial Museums and Libraries. Mr Robert F. Legget of Ottawa has given me valuable information about Colonel John By, a distant but important relative of Cooper's wife, Charlotte. I am also very grateful to the Warden and Fellows of Winchester College for allowing me to quote verbatim a manuscript letter in their possession from the fifteen-year-old Cooper to his mother.

Mrs Marylian Watney and Mr Sidney Sabin, two experienced enthusiasts of driving, the coaching era and its pictorial record, have prevented me from making too many technical gaffes in a science which they love and I have come to admire. Mr Stephen Ling of Fores Gallery and Mr F. L. Wilder have helped me in listing all the known engravings by or after Cooper Henderson, for which I am most grateful. Mr Alfred Gates and Mr David Fuller of Arthur Ackermann & Son, Mr I. R. D. Byfield and Mr John Sabin of Richard Green Gallery, Mr William Drummond and again Mr Ling have all been unstinting with their advice and help, providing photographs to illustrate the text with many fine plates and

in answering innumerable questions. I am grateful to the staffs of other London galleries who have let me use their photographs which are acknowledged with the plates.

I am indebted to many individuals who own paintings or drawings by Cooper Henderson who have lent me or allowed me to have photographs taken of their possessions. For the security of their treasures they cannot be named but this does not in any way diminish my gratitude to them, many of whom have gone out of their way to help at their own expense. The large number of plates attributed to 'Private Collection' witness their generosity. I am sorry that I have not been able to trace the owners of some of the pictures illustrated and I apologise to them; the galleries which provided the photographs have been credited in these cases.

Finally, I am very grateful to the two surviving great grandchildren of Charles Cooper Henderson, who wish to remain anonymous, for the help they have been able to give me. Since it is more than a hundred years since their artist ancestor died, their knowledge of him is limited but they have willingly shared it with me and, perhaps unwittingly, shown me his character reflected in them.

SETTING THE SCENE:

London

When writing a biography an author must decide what the reader can be expected to know of the period and surroundings of his subject. This sometimes leads to the bibliophile searching for the biography in a mass of social history of which he is already well aware. The opposite can also occur. An assumption of greater knowledge than the reader possesses may leave him without a background in which to place the hero, or examples of contemporaries' behaviour with which to relate. A balance has to be found, particularly when the biographical subject made little impact in his lifetime. This is the situation with Cooper Henderson, an amateur artist of distinction whose reputation rested on his ability to paint scenes of the open 'Road', as it was known. His work is more highly valued from every viewpoint now than in the 1840s when he was prolific and at the height of his powers. Add to this the specialised nature of the subjects of his paintings and it becomes clear that the scene must be set before concentrating on the man.

In setting the scene I have dwelt on the London of his parents and of his childhood since this is the city where he was brought up. Cooper Henderson's father and mother, and their parents before them, were well off and able to follow their own scholastic and antiquarian pursuits insulated from the harsher aspects of life which fell heavily on the working classes in London, from which Cooper's future wife was to come. As well as writing about these distinct divisions of London, the rich and the poor, it is necessary to describe the effects of the Napoleonic war which, among other consequences, limited travel on the Continent. This was a pursuit which occupied much of Cooper's parents' and grandparents' time and an activity which he continued with several visits to France. Also, more importantly, the consequences of post-war peace must be mentioned. The instability of the country and acceleration in the pace of the Industrial Revolution must have had some effect on Cooper's way of life.

Nearly all Cooper Henderson's pictures are of coaches and carriages on the road and its development in Britain, which is described, can be measured by the design and construction of the vehicles which ran on them. By 1850 Cooper's principle subjects, the mail coaches, had been displaced by the railway, coinciding with his retirement to Halliford-on-Thames after which he rarely painted.

George Keate FSA, FRS (1728–1797) was a scholar, poet, artist and antiquarian of note.

Living in Bloomsbury, he wrote much, corresponded with Voltaire with whom he had become friendly while living for some years in Geneva, made contributions to Archaeologia, collected coins and other artefacts and kept a small museum. He was a painter in gouache and watercolours and his *Sketches from Nature Taken and Coloured in a Journey to Margate, 1779* were published in two volumes. A contemporary remembered him for talking rather too much about his own writings! He owned land in Spitalfields, a village of gardened houses built by Huguenot silk-weavers, but soon to become a ghetto of overcrowded tenements and mean rookeries lacking any type of sanitation. It housed, if that is the right description, the workers who flooded into London in the early part of the nineteenth century.

At the age of forty George Keate married a merchant's daughter, Jane Catherine Hudson. A year later in 1770 their only child Georgiana Jane was born. She inherited her father's talent for drawing. His landscapes of England and abroad had been shown at the Society of Artists in the 1760s and, as an Honorary Exhibitor, thirty of his works were shown at the Royal Academy between 1770 and 1789. Georgiana was an Honorary Exhibitor at the Society of Artists in 1791 with pictures of 'May Day'; an 'Election Squabble'; a 'Scene from Shakespeare's King John'; and 'Mrs Jordan in the Character of Hippolite, Drawn from a Recollection'. As well as being an accomplished artist she was beautiful and her father commissioned first Angelica Kauffmann to paint her portrait in 1779 (a slightly insipid little girl holding a dove) and thirteen years later the pastellist John Russell drew her as the stunning charmer in Plate 1.

On the 9th of June 1796 Georgiana was married to a John Henderson (1764–1843). The Hendersons had come to London from Scotland at the beginning of the eighteenth century. John's father, Christopher Henderson, had inherited 3, Adelphi Terrace on the death of an older brother in 1784. His son was educated at home, matriculating to Queen's College, Oxford in 1783 before being admitted to the Inner Temple (1786) and graduating as a Bachelor of Civil Law in 1789. At this time James Graham, a quack doctor living at 4, Adelphi Terrace, described his house (for the benefit of potential patients more than for the architectural historian) as:

'. . . situated in the centre of that noble pile of buildings called the Royal Terrace, Adelphi . . ., light, airy, healthful and refined . . . commanding as beautiful prospect as can be conceived or anywhere seen.'

Thomas Malton's 1795 engraving of Adelphi Terrace (Plate 2) (built twenty years before by the Adam brothers), bears out Graham's account externally; inside the rooms were well proportioned and finely decorated. The terrace of eleven four-storey houses, lying between today's Robert Street and Adam Street overlooking the Victoria Embankment Gardens, was demolished in 1936.

Christopher Henderson died in 1790. His passing was described in the *Gentleman's Magazine*: 'At his home, on the Adelphi Terrace, Christopher Henderson esqr., a gentleman by amiable complacency endeared to all who knew him.' It appears that six years later his son, John, moved into the 'healthful and refined' No 4, or there may simply have been a renumbering of the houses of the terrace.

In Westminster and Whitehall the large houses reflected the wealth of their owners. The outlook from the tall windows was either over the Thames or onto open squares which were soon to be landscaped, reminding the owners of the green acres which surrounded their even more congenial country houses. However, even in Westminster there was no avoiding the dirty streets and the danger of ill-health which accompanied this problem. In the summer months when the heat gave rise to the greater likelihood of epidemics spreading those who could escape from London did so. There were, however, an increasing number of lawyers, government officials, doctors, well-to-do merchants, bankers, and minor courtiers who did not have country estates on which to withdraw for a change of air. Living the year round in London, they gave an impetus to developing the land north of Westminster into Bloomsbury and, later, westwards towards Buckingham House and to the north of the present day St James's Park. After Waterloo and during the 1820s and 1830s this expansion west and north continued with an increasing speed until Paddington, Bayswater and Knightsbridge were absorbed into a sometimes symmetrical patchwork of streets and squares of terraced Georgian houses of solid simplicity, each with its own basement, garden and mews. The last housed an assortment of town coaches, landaus, barouches, cabriolets, curricles and a host of different phaetons and gigs to suit the station and wealth of their owners. They were used for communication in the growing city and, more importantly for some, for show in the Park at 'post meridian half past four' during the Season.

For amusement, the families of the professional and middle classes entertained at home, inviting their friends to dine, to listen to music played by a visiting virtuoso or talented daughter, or to play at cards. The aristocracy and upper class held receptions and balls entertaining on a grander scale. The urgency of luring the right people to such functions was matched by the nervousness of those who came, wondering if they had chosen the most glittering party of the night.

The public entertainments of the theatre, opera, the circus and Vauxhall Gardens were for all who could pay. For those with a need to satisfy a racier taste there were gaming clubs and the prizefights of the Fancy. More exclusively, men had their clubs from which ladies were barred. As a counter-attraction there was the invitation to Almack's. The Ladies Castlereigh, Cowper and Jersey, the Countess of Lievan and Princess Esterhazy controlled these rooms where a ball and supper were given each Wednesday during the Season. Apart from ingratiating themselves to these ladies the men had to be able to dance and were required to wear knee-breeches and white cravats. Nothing less formal was allowed. Girls entering society who failed to be included on the 'List' kept by these formidable gorgons had little hope of attaining 'Fame, future, fashion, lovers, friends', as Henry Luttrell put it. However, it would be surprising if John and Georgiana Henderson had allowed their children to take part in such frivolous entertainments. Like many of the upper middle class the Hendersons may have disapproved of any behaviour verging on the dissolute. They would have found an occasional visit to the theatre a sufficiently diverting event to provide the subject of conversation for any dull days between such highlights in their lives.

In the early years of the nineteenth century the principle theatres were the Haymarket, Drury Lane and Covent Garden. Sarah Siddons, John Kemble and Edmund Kean were the

leading actors. The repertoire at Covent Garden was Shakespeare's plays interspersed with Mozart's *Don Giovanni* and *The Marriage of Figaro*, both heard for the first time in England in 1816, and Rossini's *Barber of Seville*. Disaster had struck in 1808 when the seventy-five years old Covent Garden theatre was destroyed by fire, but within two years a new theatre was built. In 1809 the same fate befell the third Drury Lane theatre; the fourth, designed by Benjamin Wyatt, opened in 1812. The productions at these theatres and others of less quality may have entertained the Hendersons sitting in their private box.

John Henderson (Plate 3)[1] welcomed the arrival of Dr Thomas Monro (1759–1833) who moved into 8, Adelphi Terrace in 1794. They became friends in the joint interest of encouraging and patronising the young and aspiring watercolourists of the day. Monro invited the teen-aged Girtin and Turner, with many others, to No 8 allowing them to copy the pictures and engravings which he had inherited from his father, to trace the outlines of Cozens' drawings and wash in colour, or to sketch views of the Thames from the balcony on the first floor. On winter evenings, arriving at 6 o'clock, the young artists would paint by candlelight, have a free run of the house, be given supper and depart at 10 o'clock with a half-crown in their pockets for their efforts. John Henderson must have spent many happy hours in this circle and sometimes invited the artists to copy his old master paintings at No 4. No doubt he also attended all the exhibitions of pictures which were available in the metropolis.

From 1700 onwards there were public exhibitions of paintings and watercolour drawings at a variety of galleries in London which were all fully reported in the journals of the period. The Society of Artists had been founded in 1753 by a William Shipley whose practice as a drawing master grew into Shipley's School. The purpose of this school was not solely to help artists to improve their skill but to foster what we would now call commercial art and design by training and introducing young artists to manufacturers of ornamental goods. A group of artists associated with the school and the older St Martin's Academy borrowed the Great Room of the Society of Arts in 1760 to exhibit and sell their work. Five years later they became the Incorporated Society of Artists and held annual exhibitions at Spring Gardens until 1773. It was at these exhibitions that George Keate showed his watercolours from 1766 to 1768. After a number of false starts during the preceding thirteen years the Royal Academy of Arts in London was founded in 1768. The Academy took a number of artists from the Incorporated Society (and a splinter Society calling themselves The Free Society of Artists) since to exhibit at the RA excluded showing elsewhere. George Keate was among those who forsook the Incorporated Society sending his works to the Royal Academy. The Incorporated Society faltered and was dissolved in 1791, the year in which Georgiana Keate showed her four pictures.

Because very little provision was made for the proper hanging of watercolours at the

[1] This drawing is inscribed: 'Drawn by C. Varley 1811 with Pt. Graphic Telescope.' Cornelius Varley (1781–1873) had worked under his uncle, a watchmaker who also made scientific instruments, until he was nineteen when he turned to his brother John's profession of watercolourist. In 1811 Cornelius took out a patent for a graphic telescope. By an ingenious arrangement of glass and a telescope, the artist was able to see the subject through the scope and an image on a piece of paper laid flat on which the outline could be traced, which is what he has done here with John Henderson. John Varley used this device to draw Dr Thomas Monro, inscribing it: 'Dr. Monro, the first Collector of Turner and Girtin's Drawings. Done with the Graphic Telescope April 12th, 1818.'

annual Academy exhibitions a number of artists formed their own society in 1804, The Society of Painters in Watercolours. This Society limited its membership to twenty-four with a smaller number of associates. Their early exhibitions at 20, Lower Brook Street and later in the Old Rooms of the Royal Academy was a great success. In 1808 they moved again to Old Bond Street since the Academy rooms had become unsafe. The exclusive nature of the Watercolour Society drove those outside the chosen few to form another in 1808 – The New Society of Painters in Miniature and Watercolours, which very quickly became The Associated Artists in Watercolour. It held its first exhibition in Lower Brook Street perpetuating the game of musical chairs of exhibition rooms. However, its existence was short-lived and it was dissolved in 1812 at the time when the older Watercolour Society was also in difficulties. In an effort to recapture its former success the Society of Painters in Watercolours proposed that oil paintings should be admitted at its exhibitions. This led to resignations and the dissolution of the Society. A caucus of senior members of the old Society with a few from the dissolved New Society immediately formed the Society of Painters in Oils and Watercolours, holding their first exhibition in 1813. They called it the Ninth, being the ninth of the old Watercolour Society's successive exhibitions. This pattern of changes, at less frequent intervals, continued almost throughout the nineteenth century.

In the meantime the Royal Academy had become well established (Cooper's father, John Henderson, exhibited from 1806 to 1814) and was one of the few vehicles, with the watercolour societies, by which promising artists could come to the notice of patrons. The annual exhibitions became one of the important engagements in the social calendar at which London society gathered to admire the pictures and each other. The popularity of the Academy and the kaleidoscope of watercolour exhibitions can be accounted for, in part, by the lack of any permanent public exhibitions until 1814. In that year Sir John Soane's Dulwich College Art Gallery was opened, followed ten years later by the National Gallery. Otherwise, collections of paintings were in private hands and while many owners were proud to show their pictures to their friends to entertain (or bore) them, the public had few chances to see any quantity of paintings or drawings except those passing through the hands of dealers or at auction houses such as Mr Christie's.

At the close of the eighteenth century the populace was concentrated in those parts of London now called the City and Westminster. This population numbered some 800,000, a figure which had risen slowly during the past quarter-century but which was soon to increase rapidly. In the City the merchants lived cheek by jowl with professional men, artisans and labourers. They all suffered from the poor housing, the lack of social recreation except that provided by the numerous coffee houses and inns and, from time to time, the scarcity of food and other goods in the shops and stalls which made the teeming streets seem even narrower than they were. Each rubbed shoulders with the next except when at home, with the Victorian nuances of position and class at their level just becoming recognisable. Every man was his own man to assert and protect himself, if necessary by fisticuffs, with the winner of a fair fight admired whether dressed in broadcloth or rags. Money could buy some advantages but the problems of bad sanitation, filthy Thames water, infection and disease were common to rich man, poor man, beggerman and thief.

In the first years of the century the maritime war led to the banks of the Thames at the east end of the City being developed into docks. In 1802 the London Dock was built at Wapping followed by the Surrey Dock two years later. The East India Dock was started in 1805, and the labour force required to work the ships, man the warehouses or handle the cargoes in this new dockland was drawn from further down-river and the villages of Essex, Kent and Surrey. The overpopulated terraces of mean houses on both sides of the River became even more crammed with resilient but very poor inhabitants. Cooper Henderson's wife Charlotte came from a background closely connected with the river life of this period. The larger properties which the merchants and sea captains left behind them as they moved west to avoid the squalor were pulled down to be replaced by courts of small, badly lit houses without gardens or any other redeeming feature. In the narrow alleyways, frequented by rats and filled with refuse (there was nowhere else to put it except the River), the dockers, lightermen, Irish labourers, coal-heavers and mudlarks together with the rest of the waterfront population and their families stoically scraped an existence which Charles Dickens was to record later with such vividness.

This short account of London sets the stage for Cooper Henderson's childhood. His family was in the upper stratum of society but not in that layer of spendthrift dandies or eccentric aristocrats so often described as typical of Regency London. They were rich but not ostentatiously so, their interests in the Arts and scholarship were deeper than that of dilettantes, and possibly they were respectable to the point of dullness. It was this last trait in their lives against which Cooper may have wished he could occasionally rebel.

The Consequences of War and Peace

In 1802 the Treaty of Amiens promised peace in Europe after the nine years of conflict which followed in the wake of the revolution in France. It was a false dawn, but its arrival brought hope however slender in the view of some politicians. The nation longed for peace and was prepared to stomach an element of appeasement in its achievement. Many began to applaud the man who saved France and Europe from the terrors of Jacobin violence which had horrified even the champions of the poor and which everyone feared. A few realised that Napoleon's campaign to dominate Europe, including Britain, had only received a temporary check.

Starved of foreign travel, the English rode in their coaches, carriages and travelling chariots to the coast, crossed the Channel and made their way to Paris. They were driven by curiosity, the tourists' spur, with an added interest of a ghoulish examination of the guillotine's slanted blade in the former Place de la Revolution. On their journey south they were agreeably surprised by the welcome they received from the peasants on the roadside, equally happy to be at peace. The fields were cultivated and the people so well ordered that some of the visitors began to wonder whether accounts of recent events had not been exaggerated. Only in the towns were there signs of the destruction wrought by the Revolution, particularly on church property. Paris itself was a delight; society had the brashness and vigour of the *nouveau riche*, and the houses were full of happy Parisians cheering their Consul and ready to be amiable to all who came to stare. For those hungry for the Arts the Louvre provided an overwhelming diet of the finest paintings and sculpture plundered from the ancient monasteries and Renaissance palaces of Italy. There was nothing to compare with these treasures in England and they made the private collections at that date look unimportant, although displayed with a more orthodox taste. Sated by what they saw, by the entertainments presented to them and by the charm of the beguiling little man so recently portrayed by Gillray as a monster, the English visitors returned to London or their country seats. They were convinced that all was well again in Europe and wished that the tiresome Lord Grenville and 'Weathercock' Windham would stop sucking their teeth over what had been given away to secure the peace for which all right-minded people longed.

A paradox of the difficulties through which the nation had passed during the hostilities

so far was that in the last three years of the eighteenth century Britain had become richer and stronger. This was manifested by a fifty per cent expansion of the value of foreign trade and a near seventy-five per cent increase in revenue. While the poor had little opportunity to appreciate this apparently beneficial aspect of war, the activity which was generated meant work and wages for nearly all those living in London and the main provincial towns.

When it was realised that an end had to be brought to the creeping annexations and sometimes violent enlargement of Napoleon's power, the lull of the Amien's agreement was broken and in 1803 Britain and France were fighting again. In prosecuting this war mainly by sea, and later on land during the Peninsula Campaign, the main effect on the country was to the economy. For twenty years the war retarded the Industrial Revolution with resources in materials and, to a lesser extent, manpower being diverted away from the manufacturing base which had been growing with remarkable speed. The virtual blockade by the Navy of the ports of western Europe and Napoleon's prevention of those countries trading with Britain meant that a number of traditional markets were closed to the predominantly middle class English merchants. Others, with some astuteness, developed trade with Africa, India and South America but there were risks in this sort of venture, not least in shipping losses on the uncertainly held high seas. With the government opening and closing markets because of the war nothing was certain. A few prospered but as many suffered for reasons which were quite beyond their control.

Taxation to pay for the war fell on the poor more heavily than the upper classes. The latter saw rents from their properties continually rising, particularly those who had land in London or in the other expanding manufacturing towns. This increase in rents and tithes from the land was not redressed by Pitt's wartime income tax. Most of the revenue required to sustain the war effort was raised by indirect taxation on consumer goods and it was the poor who felt these impositions most severely. Direct taxation provided the government with £25m in 1815 while £77m was raised by indirect taxes in the same year. As is mentioned elsewhere, Cooper Henderson's mother received an 'ample' income from her late father's Keate Estate in Spitalfields, and it is unlikely that the family was in any way financially inconvenienced by the war. No doubt they were well aware of it and had compassion for those who worked for very little reward in the new docks which were so essential in maintaining the fleet which prevented invasion.

In the country the effects of the war were even less obvious. The now fast rising population of the towns required feeding and better use had to be made of the soil. This was achieved in part by the continued enclosure of the land. Where the smallholder or cottager was no longer able to survive on his own half acre or the common land there was usually work in the local town. The wages might have appeared adequate compared with those in the country but the conditions were far worse, but this was of little concern except to the few philanthropic land or factory owners. Among the more prosperous families, second sons found themselves with regiments in the Peninsula but other members were able to enjoy a variety of country pursuits untouched by war. This was the golden age of hunting, coursing and shooting, with races to attend and wagers to be made, often for extremely large sums for matters of trifling importance except to the contestants. There is evidence that Cooper

Henderson took part in some of these activities since the authenticity in his painting of them could only have come from first hand knowledge and experience. It was also a time when country houses were enlarged, replete with libraries, rooms of paintings by Ben Marshall and John Ferneley and galleries of English portraits or Old Masters for the more discerning. It was a period when in the country there was more food than would be decently eaten by modern standards, more patronage than the present day can tolerate and more amusement than today's townee would think the countryman deserved. The effect of the war was minimal.

The consequences of peace, which were felt even before Waterloo in 1815, were a ruinous fall in prices of both manufactured goods and agricultural products. For a short time the purchasing power of wages was relatively increased, but thousands soon found themselves out of work for reasons of the economy or, in their view, the introduction of machinery replacing their manual skills. The protectionist purpose of the Corn Law preventing cheap grain entering the country enabled the landowners to increase the cost of their produce. This led to unrest and subsequently a realisation that the poor had no way of influencing the policies of the government. Income tax was abolished in 1816 throwing an even heavier proportion of raising the national income on indirect taxation which the less well off could least afford to pay. William Cobbett and others voiced their predicament but the victors of Waterloo applied repression of almost anti-Jacobin severity which stifled free speech and from which tragedies such as Peterloo followed. In 1819, a large but orderly gathering declaring the need for Parliamentary reform at St Peter's Field, Manchester was ridden down by the Yeomanry ordered in by the nervous magistrates. Twelve citizens died and many more were injured in this unnecessary suppression of the Englishman's most coveted right to freely voice an opinion.

It can be postulated that if there had been no war these events would have occurred much sooner than they did. If this had been so the explosion in the size of the population, its changing character and the material divide between rich and poor combined with the Industrial Revolution moving at a faster pace, might have made Cooper's childhood more turbulent than it was. In fact, the repressive effect of the war made his early years relatively tranquil in his parents' level of society. The turmoil of peace arrived when he was in his teens and at an impressionable age but, like so many well-to-do families in London or the country, the Hendersons were again as untroubled by these disturbances as they had been by the consequences of war.

The Open Road

It is in many ways extraordinary that in Britain no roads were built between the time of the Roman occupation and the introduction of the Turnpike system in the seventeenth and eighteenth centuries. The Roman roads, once elevated highways from coast to coast, fell out of use. Some deteriorated into pack-horse tracks and others disappeared altogether because their stone was removed and used for other purposes. The need for adequate roads was apparent in the sixteenth century when Queen Elizabeth made her Royal Progresses in the southern counties, often by coach. At the end of her reign heavy, four-wheeled waggons drawn by eight or more horses were jolting their loads of grain and other produce across the country and from inland towns to the seaports. The inhabitants of the country towns and villages through which these trackways ran were not happy to find themselves responsible for their maintenance. Cromwell's armies discovered how much the bad condition of the roads slowed and restricted their movement and when they came to power they passed an Act in 1654 empowering the Justices to raise revenue locally for repairing them. This Act was re-enacted in 1662 at the Restoration. By the middle of the seventeenth century so-called stage coaches were on the roads but travel was slow, uncomfortable and in winter almost impossible. The coaches were heavy but strong, built to contend with the rutted and rough surfaces, but their weight as much as the poor roads over which they travelled limited their speed. Although there was dissatisfaction about the need to maintain the roads in the country this was eased by the realisation that prosperity could be derived from the pockets of travellers who passed through the villages and towns astride them.

The old North Road from London to Berwick was the first turnpike where tolls were gathered (not very successfully) to pay for its repair. This was in 1663. The toll system was resented and avoided, and it was not until 1693 that the Turnpike Act became law. In the same way that the inadequacy of the roads had been noted by the Commonwealth, the 1745 Rebellion again highlighted the need for their improvement, particularly in the north of England where roadmaking and mending lagged behind the south. It was not until the second half of the eighteenth century that a major increase in the number of Turnpike Trusts was achieved culminating in the General Turnpike Act in 1773. In this Act it was accepted that it was necessary to make and maintain through routes and roads which would have to be funded by money raised by taxation.

Further impetus was given to improving the roads when John Palmer of Bath, sometime manager of the Bath and Bristol Theatres, finally persuaded the reluctant and conservative officials of the Post Office of the efficiency of sending mail by coaches. Letters had previously been carried by mounted postmen who were unpunctual, often held up and robbed by highwaymen, and were generally a poor means of meeting the growing need to distribute business and private correspondence quickly. The first mail-carrying coach ran on the London to Bath route in 1784 and proved a success. It travelled at about seven miles per hour, twice the average speed of a mounted postman. This coach, and the many mail coaches which followed on all the main roads across the country carried passengers whose fares helped to defray the cost of sending the letters by this means. In 1786 Palmer was made Controller General of the Post Office and by the end of the century eighty mail coaches left London every evening for the provincial towns and cities. The mail was in the charge of the Post Office Guard, armed with blunderbuss and horn or key bugle, whose strict responsibility it was to ensure that the letters reached their destinations at the times prescribed, come what may. The 'Mails', as they were known, paid no tolls and one of the purposes of the guard's horn was to give warning to the sleepy gate-keeper that he must have the gate open to allow the coach to pass through at speed – the subject of a number of paintings by Cooper Henderson (Plates 11 and 48).

Neither the Justices raising local revenue nor, later, the Turnpike Trusts obtaining income through tolls provided the panacea for good roads. Very little scientific thought was given to this subject since the financial rewards of doing so appeared small. There was some experimentation which can be described as either imaginative or ridiculous. In the mid-eighteenth century, taking the example of the raised Roman road construction as a start point, some convex, rough stone-surfaced roads were built with the idea that this shape would provide good drainage to the road sides. However, the wheels of the coaches and waggons scattered the unsupported top stone left and right, which had to be frequently replaced, and when a vehicle had to leave the centre of this highway to pass another it leaned at an angle which was dangerous to its stability. The ridiculous solution was an opposite arrangement of the road surface sloping inwards to a central 'drain'. Water flowing in this drain was meant to provide a smooth surface in the same way that a river bed sometimes becomes flat and hard with the passage of swiftly flowing water over it. These roads disappeared as fast as they were built!

John Metcalf had followed a number of trades and occupations before he turned to road making in Yorkshire. He understood the need to follow the natural contour of the ground to provide the most stable foundation for a road. His ability to survey many miles of road in this fashion was all the more remarkable since he was blind. Metcalf died in 1810. His near contemporaries were Thomas Telford (1757–1834) and John Loudon McAdam (1757–1836). They are recognised as the road makers who had the most marked effect and made the greatest difference to the comfort and speed of travel in the early years of the nineteenth century. Like Metcalf, Telford believed that good foundations were the key to making all-weather roads. He placed a gravel surface on a six-inch layer of broken stone, itself resting on a base of larger stones. The gradation of stones and the camber of the surface

allowed for drainage. McAdam took a different view. He believed the surface was the most important element in road building. By using small pieces of hard stone tightly compacted he produced a flat and weather-resistant surface which could be laid on any or no foundation. Both men had immense energy, as had Metcalf, and between them they revolutionised road communication on the main routes of the country. This did not take place overnight but by 1827 when McAdam was made Surveyor General of Roads, the network of turnpikes resulted in the possibility of lighter coaches and carriages and much faster speeds being achieved. The Mails now travelled at twelve miles per hour and journeys which had been measured in days became a matter of hours.

In March 1818, when Cooper Henderson was a commoner at Winchester College, he wrote to his mother:

> 'Pray tell my father I should have written to him at Bath if I had had the time but now if I was to write it is ten to one he would not get it and tell him since I received his I have been happy as the day is long. . . .'

Cooper's slightly transparent excuse for not writing to Bath suggests that either the mail was slow (via London), but he had received a letter from his father, or that John Henderson stayed in that city for only a short time. The road between London and Bath was not yet at its best; that is to say, ten or so years later the journey was accomplished by the London-Bath-Devonport or London-Bristol-Pembroke Mails and by stage coaches in ten and a half to eleven hours. John Henderson may have used his own carriage to visit the Spa but the expense of hiring the changes of post-horses would have been considerable. It is probable that he went by coach. The distance to Bath from Hyde Park Corner was 106 or 107¼ miles dependent upon the route taken. For the first 81 miles the road was the same but at Beckhampton Inn, six miles west of Marlborough, one could reach Bath via Devizes and Melksham, the southern route, or by Chippenham, the shorter northern road. By Mail, John Henderson would have started his journey at the Swan with Two Necks, Lad Lane and by Stage from this inn or a number of others including the famous Bull and Mouth in St Martin's-le-Grand, the Belle Sauvage in Ludgate Hill and the Spread Eagle, Gracechurch Street. The road ran through Knightsbridge, Kensington and Hammersmith, then to Brentford and over the Grand Junction Canal to Hounslow and the Heath beyond. Hounslow Heath had once been highwaymen's territory where horsemen and private coaches were robbed with alarming regularity; however, stories of Mails being held up have been romanticised and exaggerated. John Henderson would have crossed the Heath with few qualms in 1818, confident that the Guard's blunderbuss was sufficient insurance to deter any outrage. Between Longford and Colnbrook the road crossed the River Coln into Buckinghamshire. Sixty years before, long stretches of the road to Bath were either quagmires in the winter (but commended for being only two feet deep in mud) and dustbaths in the summer. To extend the successful winter season in Bath, Beau Nash had water pumps put up along the road to douse the dust which would otherwise have put off the fashionable world from visiting the city. Until recently some of these pumps could still be seen near Colnbrook and Longford where the old road had not been lost beneath modern development. From Colnbrook the road ran through the village of Slough, past Eton and

Windsor to Salt Hill before crossing the Thames a mile east of Maidenhead. Maidenhead Thicket had a similar reputation to Hounslow Heath but thereafter the road was open to Reading, Newbury and Hungerford before passing through part of Savernake Forest and dropping down into Marlborough. On the way to Beckhampton Inn the route followed the old Roman road making an unusual curve to avoid Silbury Hill, the 170 feet high conical, man-made earthwork of unknown date and significance. From the Inn the road crossed the open chalk downs to Devizes, then to Melksham and past the sites of the Roman villas at Atworth and Box before reaching John Henderson's journey's end and the destination of his son Cooper's unwritten letter, Bath.

To complete this journey in eleven hours (in 1818 it may have taken longer) would necessitate at least as many changes of horses, probably a few more. These changes provided the briefest respite from the jolting of the coach which made the one longer halt allowed at a wayside inn all the more attractive. Henderson's journey, and return, were typical of hundreds which took place each day to all the principle towns and ports of the country. The roads ran like the spokes of a wheel from the central hub, London. There were also many cross-country and local Mail and Stage Coach routes supplementing the main turnpikes; no less than seventeen coaches ran daily in and out of Bath. In 1835, 700 Mails and 3300 Coaches, needing 150,000 horses and 30,000 men to ensure their efficient running, used this vast network of well-made roads. Added to which were hundreds of heavy, slow stage waggons and a host of private coaches, carriages, gigs and brakes which, on the busier routes, must have provided a spectacle of incessant movement, bustle and noise equal to that on a main road today.

At the start of the Industrial Revolution only those towns with raw materials which could be drawn from the surrounding countryside thrived. The roads were inadequate to provide ways of transporting heavy loads or merchandise. While woollen and cotton products could be carried by pack-horse, anything weightier or with an awkward shape had to be conveyed in eight- or ten-horse waggons which made slow progress and often damaged the roads they used. During the lasty forty years of the eighteenth century the situation improved with the building of canals in a system which joined many of the natural waterways of the country as well as making new routes in themselves. Coal which was in enormous demand had previously been transported laboriously to coastal ports to be taken to London and other towns served by rivers but distant from the coal-fields. It was now despatched by barge in a spider's web of canals and rivers not much less comprehensive than the later turnpike roads. By the mid-nineteenth century there were over 4000 miles of inland waterways which were also used by packet boats giving an alternative method of travel to passengers not in a hurry. The canals alleviated some of the difficulties which coaches encountered when they met or tried to pass stage waggons on the road. Because of their sluggish speed and size these heavy vehicles interfered with the fast passage of the Mails which had nominal right of way; a situation which has its parallel today.

The purpose of the first railways was also to distribute coal and heavy materials, and to provide routes where there were gaps in the canal system. The first line from Stockton to Darlington was opened in 1825 to carry freight and the Liverpool to Manchester railway

carried more goods than passengers in 1830. One reason for the slow build up of passenger traffic was that many of the freight routes were not those useful to the populations of the towns they connected. Also the early railway carriages were no more comfortable than travelling on the outside of a coach and fears of derailment (Plate 92), accidents or other misadventure were sedulously broadcast by the coach proprietors who recognised the threat to their own trade. However, in the 1840s when the boom of building lines began (and the wiser coachmen invested in them), and when the fares charged were considerably less than for the same distances by coach, the public deserted the open road. There were still many coaches on the byways and cross-country routes and to the towns which were some distance from a railhead. Equally, some of the London stations were not built until the 1850s and 1860s so that passengers had to be taken by horse omnibus to the termini in what are now the suburbs of the metropolis. Just as the canal system had in some respects overtaken the network of roads, so the railways overtook and took over the roles of both.

Coaches and Carriages

The majority of the scenes of the Open Road painted by Cooper Henderson are Mails and Stage Coaches, the latter were known simply as 'Coaches' in their golden age. Until the institution of the post being carried by the Mails, coaches which derived from those used in the first Elizabethan era were cumbersome affairs drawn by up to three pairs of heavy horses. These vehicles became known as Town Coaches and were owned by the nobility who could afford them. When an improved version was built the older ones were discarded and often employed as coaches for hire, being called a Hackney coach, after the French 'haquenee' which is a horse for hire. Hackney cabs which were smaller, purpose-built vehicles came onto the streets of London at the beginning of the nineteenth century. The Mail Coaches, introduced in 1784, were specially built by a John Vidler at Millbank. These Mails were quite light in weight, and tall and narrow in construction. They were able to carry four passengers *vis-à-vis* inside and four outside: one beside the coachman (the most favoured position) on the boxseat and three immediately behind on the roof seat facing forward. The guard had an individual seat at the back with his feet resting firmly on the boot in which the letters and packages were locked. The royal livery of the Mails was black with maroon doors and panelling; the undercarriage and the wheels were scarlet. The royal coat-of-arms was painted on the doors together with the words: Royal Mail, and often the destination of the coach. The Royal Cipher was emblazoned on the side of the box below the coachman's seat and the number of the Mail below the guard. The insignia of two of the four Orders of Knighthood were painted on each side of the doors on the black hood. They were elegant vehicles but because of their narrowness it was not surprising that in an accident they sometimes tipped onto their sides propelling the outside passengers into the ditch or farther afield. Vidler built and was responsible for the repair of the Mails which the Post Office in turn sold to the mail contractors, but maintaining a tight control over them and providing the guards. In the modern idiom, the Post Office was determined to have its cake and eat it with a monopoly of the service but without responsibility for the vehicles which made it possible.

At first, coaches were the successors of the Town Coach but later the Mail design was copied. With the prime requirement to carry passengers, the Coaches were heavier vehicles in order to provide the accommodation inside and outside for as many people as possible.

They were often painted in brilliant colours at the whim of their proprietor. They had names such as The Tally-ho, The Age, The Wonder, The Defiance, Red Rover and a rash of Telegraphs, Rockets and Regulators painted in large letters on a panel behind the back seat and sometimes under the coachman's footboard. The side panels showed the main stopping places of the journey and the door panel usually had a small picture of the motif of the inn from which the proprietor carried out his business. Beside the doors were the licence plates. The smartest and best regulated Coaches aped the Mails which were the discreet dandies of the road. They did not have their quiet distinction but in the end outlived them in the railway age.

Another vehicle regularly painted by Cooper Henderson was the Travelling Chariot, a private carriage drawn by a pair or four, usually with postillions riding the nearside horses. Those who could afford these chariots found posting with their well-sprung bodies and beautifully upholstered interiors the most comfortable way to travel any distance. There was a forward-facing seat for two passengers who were able to see the passing countryside through the large windows at the front and above the side doors. Some luggage could be placed on the roof and beneath a seat at the back where two servants could ride in the open. While an owner might use his own horses for the first and second stages of a journey, he would rely on changing teams at the Posting Houses along the route. Many of Henderson's paintings of travel on the Continent show these Travelling Chariots at speed as the occupants progress on their Grand Tour. A courier led the way and would be responsible for making all the forward arrangements for a trouble-free and successful itinerary to be followed. Two other travelling carriages of the period were the Britchka from Austria and the Dormeuse from France. The first allowed the passengers to lie full length on the floor of the vehicle during long journeys or at night under a slightly complicated but efficient arrangement of hoods and windows which could be raised quickly in bad weather. The Dormeuse had the similar advantages of the Britchka with those inside sleeping prone but with a fixed hood, like a Travelling Chariot, on which baggage could be carried. It also had a hooded rear seat for servants. Both these carriages could be driven from a box or by a riding postillion. A Travelling Chariot which was no longer required by its owner was usually bought by an inn-keeper and employed as a Post-Chaise; that is a vehicle which could be hired and for which there was exactly the same arrangement for postillions and teams of horses as in its original role. These vehicles were nearly always painted bright yellow from which their nickname 'Yellow Bounder' arose.

There is a tendency to call any French coach of the period a Diligence, whether it looks like an English chariot or omnibus. Cooper Henderson's exhibit at the Royal Academy in 1848 was titled: 'The Diligence of 1830', and this three-bodied heavy coach was the type which he used most often as his model in paintings of the French road. They were enormous vehicles. The bodies of two coaches with a half-coach at the front were mounted on a wooden unsprung chassis supporting two axles. There were four very strong wheels, the front pair smaller than those at the back as with most coaches and carriages. Like a Travelling Chariot, the half-coach had forward-looking windows, the centre body door lights and the doorless rear body sometimes had round or oval lights. Above the half-coach up to four

passengers sat perched under a folding hood looking over the heads of the team far below, perhaps with feelings of vertigo. Behind the hood there was room for more passengers to stand or squat with their backs against the baggage which was piled on the remaining length of the coach roofs, covered by tarpaulins. The destinations of these great galleons of the road were painted on their red, green or yellow-banded sides, and a single lantern hung high over the front windows to light the way. The usual formation of the horses was four leaders abreast and two wheelers with a postillion riding the nearside wheeler taking the place of a coachman. The number of people these diligences could carry varied but however many there were they cannot have expected to be transported quickly. Cooper Henderson painted the teams at a crisp trot but this must have been more in hope than expectation with four or five tons to pull over the generally poor roads of France.

The much smaller Malle Poste was an altogether more dashing vehicle (Plate 47) not unlike an English Post-Chaise. Although always depicted as being driven furiously by a usually bucolic looking postillion, there can have been very little comfort for the inside passengers as they rattled over the *pavé*. However their *élan* was much the same as the Mails and Cooper Henderson obviously enjoyed painting them.

The illustrations in this book show a greater variety of carriages and coaches than described here and it should be remembered that their designs were continually evolving. Speed was a more important factor than comfort on the road and vice versa for town or park use. From the mid-eighteenth to the mid-nineteenth centuries the advances in road travel were not dramatic by our experience today, but for Henderson they must have provided an exciting challenge in recording the Open Road during the first fifty years of his life.

LIFE AND WORK:

The Early Years

1803–1830

After three years of declining health, Georgiana Henderson's father died at his house 10, Charlotte Street, Bloomsbury on the 28th of June 1797. George Keate was buried at Isleworth where he had lived as a child. Undoubtedly he influenced his daughter's early life leading to a marriage where the interests of husband and wife could hardly have coincided more closely; interests which were to be perpetuated with an unusual exactness by their first child, John, who was born on the 1st of December of the same year.

In 1798 the Hendersons left Adelphi Terrace. They may have been tired of London affected by the administration grappling with the greatest military power yet known across the Channel, or perhaps the house by the Thames was less airy and healthful than James Graham had promised his patients, an important factor if Georgiana was to successfully bear more children. They moved with her mother to Hadley near Barnet, then a country village but within an easy carriage ride of the aesthetic and artistic attractions of the metropolis. Two daughters were born at Hadley: Georgiana in October 1798 and Jane Catherine in November 1799. Jane Keate died in 1800 and the Hendersons moved again. In 1802, John Henderson leased the Abbey House at Chertsey in Surrey from a William Barwell and here, while the country feared an invasion from Boulogne by Napoleon's 120,000 strong Army, Charles Cooper was born on the 17th of June 1803.

It was a hot and restless summer. By the autumn countless volunteers were drilling in the Home Counties and elsewhere, militiamen were marching and counter-marching in Sussex and Major-General John Moore was finalising the training of a specially formed Light Brigade to harass the advancing enemy should they reach the fields of Kent. The invasion fever affected everybody and did not subside until the following spring as Napoleon struggled, and failed, to concentrate a battle fleet to escort his flat-bottomed barges across the Channel so narrow yet impassable in the face of English naval supremacy.

With the passing of the crisis and the completion of his family, John Henderson returned to London. Bedford House which looked south on Bloomsbury Square had been demolished in 1800. Three years later the Duke of Bedford (a private in the Volunteers) developed the gardens of the old house. The well-proportioned terraces of Montague Street were built by James Burton on part of this land in 1803 and 1804. They were, and are, excellent, plain examples of Georgian town architecture, four storeys, with the ground floor

stuccoed (Plate 4). The gardens of these houses backed onto the old site of Montague House where the British Museum had been established for fifty years. The proximity of the Museum may have been one of the reasons for John Henderson deciding to take the recently completed 3 Montague Street in 1804. Hendersons lived in the house for the next seventy-five years.

Despite the problems of the apparently endless war abroad and the difficulties this produced at home, it is easy to imagine the quiet, ordered life of the Hendersons and their growing children at No 3. John Henderson resumed his enthusiasm for watercolour drawing and again took an interest in the work of the young artists whom Dr Monro continued to encourage at Adelphi Terrace. Georgiana, with the help of parlourmaids, a cook, nurses and a governess was able to pursue her own enjoyment of the Arts. When John and Cooper were older their father supervised their early education by engaging tutors and a young drawing master, Samuel Prout. It was quickly evident that John would follow his father in all his intellectual pursuits, except that he was less able with the brush. Cooper may not have been

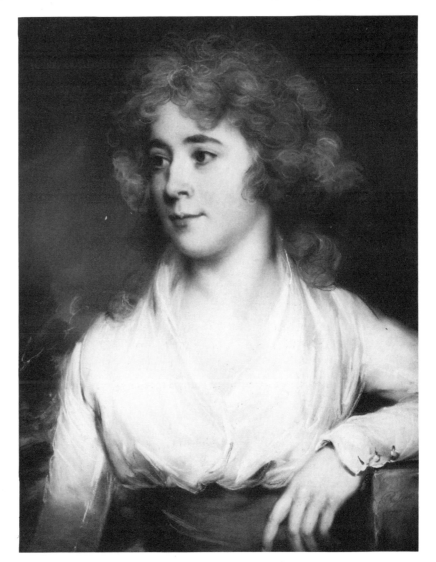

I **Georgiana Keate
aged 21 years.**

Pastel by John Russell RA

Private Collection

see page 18

so happy with the scholastic routine and was probably more interested in what he could see out of the large sash windows of their comfortable home: the passing populace; street sellers; smart carriages and humble carts; and the few urchins bold enough to explore the dusty streets leading into Russell Square recently laid out by Humphrey Repton in the new landscape style. The only unsatisfactory aspect of their lives was that they could not travel in Europe while Napoleon dominated the Continent. They longed to see the sights of France, Switzerland and Austria which had inspired the painters whose work they were set to copy by their father, or to explore those areas of Italy and Greece which played such an important part in their classical education. They were limited to visiting the more picturesque mountains and lakes of Britain. John Henderson Snr was in the Lake District in 1806 and from his exhibited work he obviously spent much time depicting coastal scenes – some garrisoned against sea-borne invasion.

In an essay about Cooper Henderson in *Baily's Magazine* of September 1895 (reproduced on page 116), Sir Walter Gilbey writes that Cooper was sent to school in Brighton and

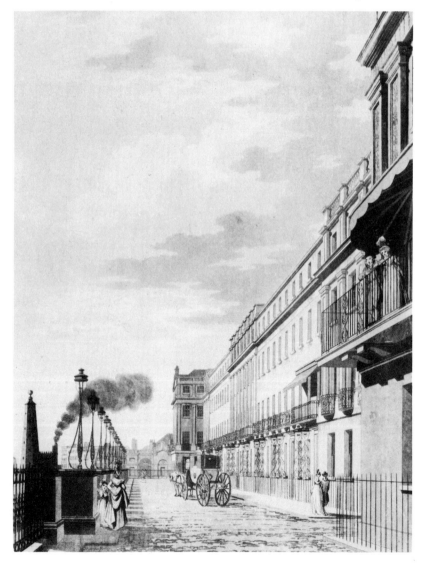

2 **The Adelphi Terrace 1795**

by Thomas Malton

Guildhall Library, City of London

See page 18

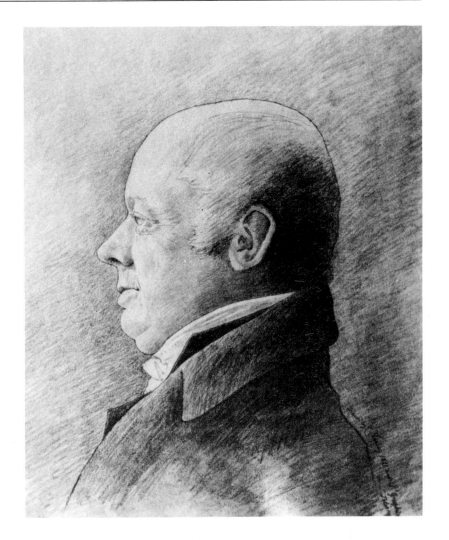

3 **A pencil Sketch of John Henderson, 1811.**

British Museum

See page 20

while there drew a picture of a well-known local character 'The Mousetrap Man' so well that it was engraved and published. It is probable that the Hendersons left London in the summer months sometimes to stay at Brighton where the Prince of Wales, soon to become Regent, entertained the *haute monde* in the exquisite and extraordinary pavilion which he was building, but John and Georgiana would not have sought this circle in spite of the Prince's enthusiasm and patronage of the Arts. Whatever the case, the young Cooper at school or on holiday was soon drawing what he saw about him. Brighton, which was a town of 14,000 people in 1811, must have been an entertaining place with the widest range of human subjects imaginable; far more exciting perhaps than those whom he saw in the halls of the British Museum or his father's house. Already, like his mother, Cooper enjoyed drawing people more than landscapes however much his father considered the latter to be the superior skill and hoped that both his sons would attain a similar ability to his own, which was considerable.

In early 1818 Cooper went to Winchester College following in the path of his elder brother John who had gone up to Balliol College, Oxford in 1813. At fourteen and a half years, Cooper was slightly older than the other boys who entered as commoners with him.

The unremitting fare of classics with a little mathematics taught by the writing master must have been daunting. There was no drawing master until 1824 when a Richard Baigent was appointed. In a letter to his mother in March 1818 (reproduced on page 114), Cooper seems happy enough. He gives a detailed description of the college geography, the daily routine and an opinion of his tutors. The letter is full of small inky sketches and crossings out but a dearth of stops. It was written in the sickroom: 'I was going to get some bread at hatch and there was a great crowd and one of them seeing I wanted du pain kindly stood on my toes.' The excruciating schoolboy pun shows humour, and he found the sickroom to be a very pleasant haven for a few days. He suggests: 'you can employ John the lawyer' to help decipher 'my scrawl and put 6d into his pocket for his trouble.' Elsewhere he writes: 'I beg to be remembered kindly to Mr Prout who I hope is quite well tell him I shall never be able to repay his attention, and thank him sufficiently for his trouble he took with me and my etchings.' In this letter Cooper is in good spirits and feels he is fortunate in nearly everything. 'I was under the worst tutor here but he having more than his regular number

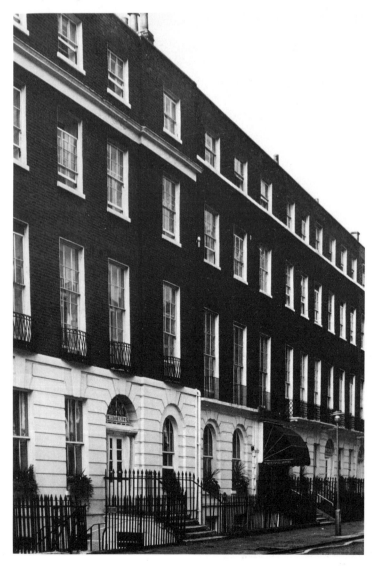

4 **No. 3, Montague Street, London**

Photo by the Author

See page 35

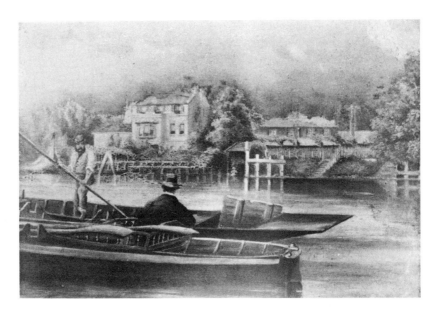

5 **Halliford Bend in about 1860**

by Charles Cooper Henderson Jnr

Private Collection

See page 73

gave me up to Mr John Williams who is the most clever tutor of the three good luck again you see, so I am sure I ought to complain of nothing.' His luck changed when Williams was dismissed being held largely responsible for the rebellion that occurred at the college in May 1818. The Warden, Mr Gabell, was a mean and spiteful man who enjoyed tricking the boys until they could stand it no longer which lead to the revolt. After an inquiry Gabell was also dismissed, but one suspects that the governors could not support a master who may have taken the side of the boys however much they had been provoked. Williams may have been made a scapegoat because he was not a Wykemist. A few years later he became Headmaster of Edinburgh Academy where he was very successful.

To go home or return to Winchester Cooper probably travelled by coach. With his fast

6 **Halliford Bend Today**

Photo by the author

See page 73

growing interest in the life of the Road he may have persuaded his father to allow him to ride on the outside of a Mail or one of the Southampton coaches. The roads did not yet allow the high speeds of a few years later. McAdam's construction of roads was only approved in 1818. However, these journeys to Winchester would have been sufficiently exhilarating to blunt Cooper's sadness at leaving Montague Street.

In October 1818 he is less happy, and perhaps with good reason. 'Our holidays are put off a week later, I believe, so that it will be about the 21st' [of December] 'that we leave this enchanting hole. . . . I write to learn news of you, not to give you any, for what can I, shut up in a yard have to say. A canary in a cage cannot tell its friends what it thinks of the country. . . .' At least his punctuation is improving! Cooper left Winchester a year later.

The Basevis lived at 8 Montague Street. George Basevi Jnr (1794–1845) who was a pupil of the architect Sir John Soane in 1811, toured Italy and Greece from 1816 to 1819. His younger brother, Nathaniel Basevi, was a contemporary of John Henderson Jnr at Balliol and, like John, destined for a career in law. It is probable that George Basevi's account of his three years abroad provided the stimulus to persuade John Henderson Snr that the time had come for a Grand Tour of the Continent for his two sons, and possibly Georgiana and their daughters. He had been abroad on a number of occasions before but may have been too busy with his family to join the throng which filled the Dover road with coaches and carriages destined to see the new France after the Amiens agreement. He exhibited a scene from Switzerland at the Royal Academy in 1807 but it is unlikely that he could have been in that country during the previous few years.

The first requirement was to employ a good courier, possibly an Italian, Swiss, German or Frenchman who could speak three or four languages and knew the continental roads to organise the route. He was also required to provide the relays of post-horses, order the hotel rooms in advance and settle the bills himself rendering a periodical account for the money given to him. The Hendersons could have travelled in a hired coach such as the Dormeuse already described, but Cooper's many paintings of continental travel often show an English Travelling Chariot. This is the vehicle in which they probably posted from Calais to Marseilles and on to Italy, returning through Switzerland, Austria, Germany and again France with a stay in Paris. In these paintings and watercolours the courier can be seen riding ahead (Plate 33) clearing the way in his blue jacket trimmed with gold, a red waistcoat similarly embellished and a cap with chin strap and flaps to pull down over the ears and neck in bad weather. The poor state of the roads varying from dusty track to Alpine pass, combined with an assortment of post-horses, good or downright bad if the courier was not doing his job properly, made the journey slow. The advantage of this to Cooper was the ample opportunity to sketch whatever caught his eye. He was fascinated by everything he saw, the postillions and muleteers at work, the peasants in their bright costumes and the variety of vehicles, horses and accoutrements – all were noted in his drawing books. His father and brother were concentrating on the scenery, admiring the majestic landscape, searching out ruins and vistas and examining antiquities while Cooper was immersed in the people, the excitement and the hurly-burly of the tour. Perhaps for some of the time he was

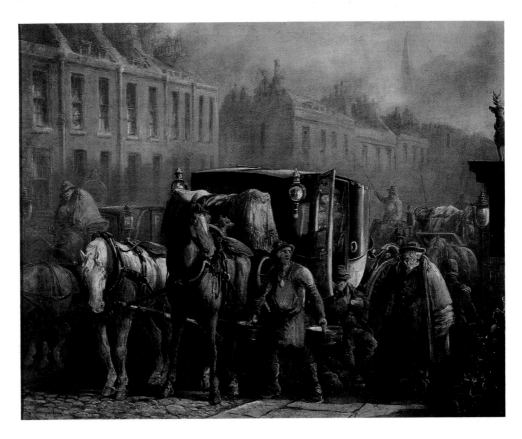

A pair:

7 **The Hackney Stand.** Oil on canvas, monogram on waterbucket, 16½ × 20½ inches

8 **Loading the Diligence.** Oil on canvas, monogram on a basket, 16½ × 20½ inches

Loaned to the British Sporting Art Trust by V. Morley Lawson Esq.

See pages 45, 57 and 58

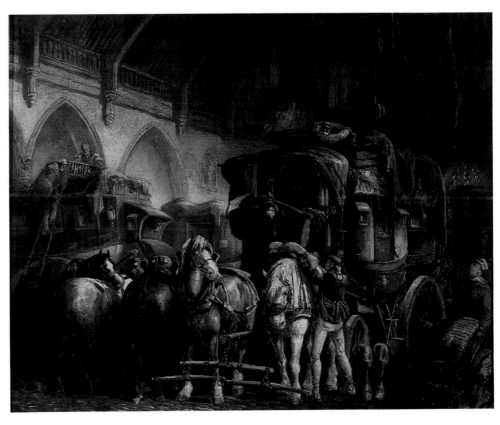

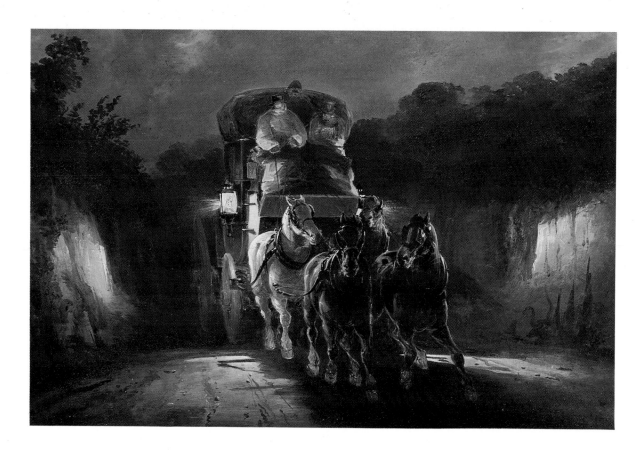

A pair:

9 **The Night Team.** Oil on canvas, monogram on tarpaulin, 12 × 18¼ inches

10 **Day Stage.** Oil on canvas, monogram on baggage, 12 × 18¼ inches

Richard Green, London. See page 59

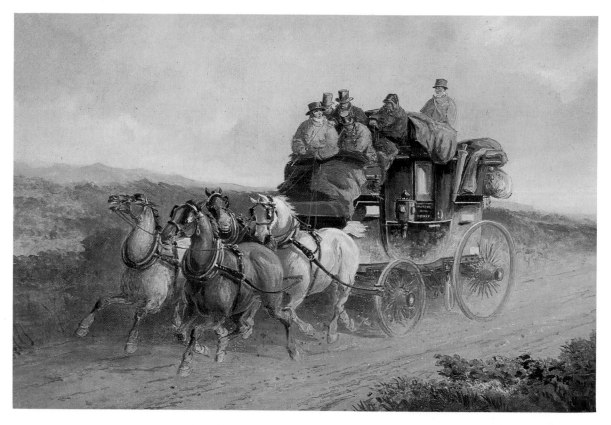

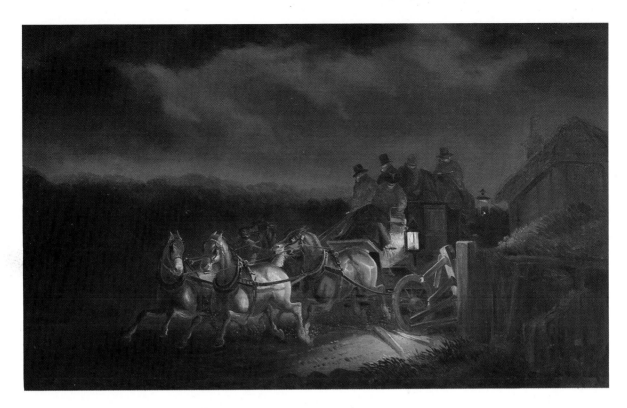

11 **A Mail breaking the Turnpike Gate**

Oil on canvas, monogram on baggage, 13½ × 23½ inches

Private Collection. See page 27

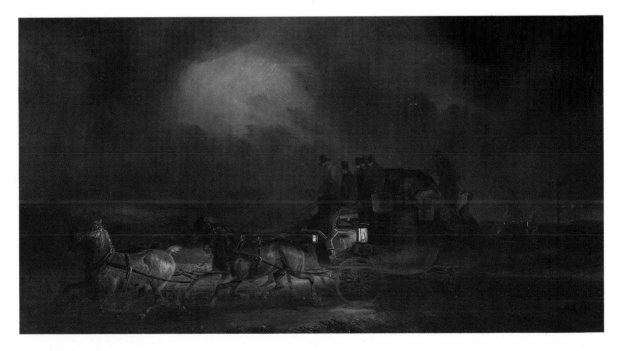

12 **The Night Mail Passing a Whiskey on the Road**

Oil on canvas, monogram on baggage, 13 × 24 inches

Richard Green, London

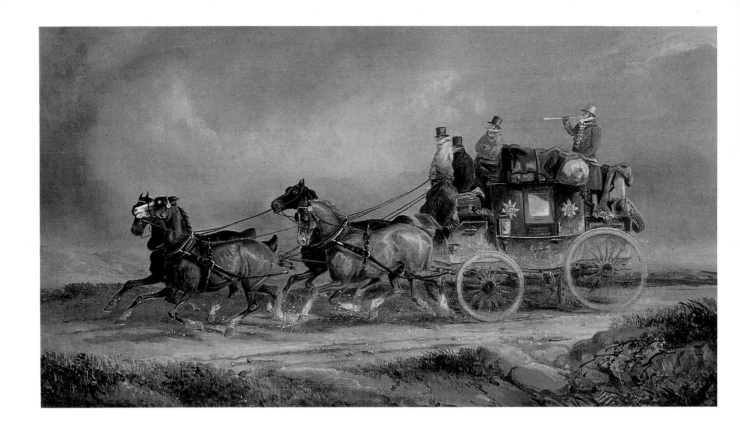

A pair:

13 **Royal Mail at Speed.** Oil on canvas, monogram on baggage, 9¾ × 17¾ inches

14 **Stage Coach Travelling.** Oil on canvas, monogram on baggage, 9¾ × 17¾ inches

Richard Green, London

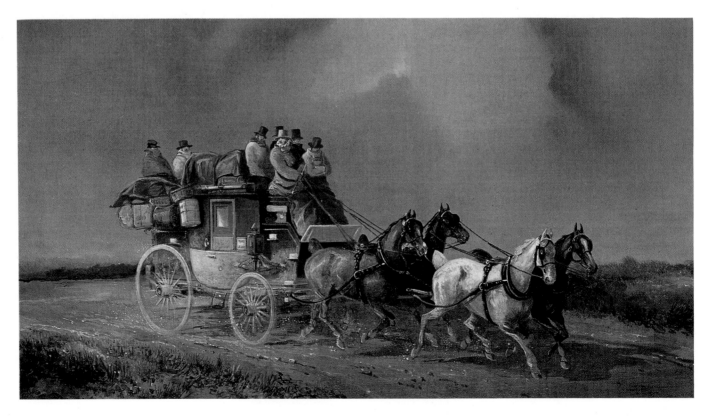

prevailed upon to sketch the scenery for there are etchings in the British Museum by his hand of Sospello, Drakenfels and Lake Como; but they are not very good.

In later years the vigour with which Cooper painted horses suggests that he admired the work of Theodore Gericault. Gericault visited England from 1820 to 1822 when the Hendersons were probably on the Continent but Cooper may have seen his work in Paris or reproductions at a later date. It seems unlikely that they met. Gericault died in 1824 at the age of thirty-three having made a lasting impression on many artists with far greater talent than Cooper could ever hope to emulate. However, his visit to the Continent and the probability of seeing Gericault's work may have been an important milestone in Cooper's education. Apart from help from Samuel Prout and his father with figures and landscape, he was self-taught as an animal painter.

This tour with his father and brother was not the only occasion that Cooper travelled abroad. On the contrary, there is evidence that he returned to France in 1824 and there were many other visits to lighten the tedium of studying for the Bar under Nathanial Basevi in London, although Cooper was never admitted to one of the Inns of Court. He loved France and in later years took his children there on holiday.

Apart from 'The Mousetrap Man', the earliest published work I have seen after Cooper Henderson's painting is dated 1827. This is a lithograph from a watercolour, coloured by hand, titled 'Place de Fiacres', printed by C. Hullmandell and published by S. Pearse of 31, Conduit Street, London. This slightly crude but interesting scene (Plate 72), with its amusing sign of the 'Maison D'education des Jeunes Demoiselles', may be one of Cooper's earliest attempts to introduce vehicles into a street scene – a coach and Cabriolet. When the Cabriolet came to England it was thought to require a large, well-bred horse for such a smart turnout; in the 'Place de Fiacres' the French plainly set little store by this utilitarian vehicle with its tired jade. The coach too is rudimentary. To put the scene into perspective and to illustrate why Frenchmen envied the English traveller, coaches in England were approaching their best in terms of speed, punctuality and comfort. Also the first railway line in Britain had been opened two years before this print was published while travel in France remained stubbornly slow and unimpressive. In the same year (1827) Pearse published three small etchings (and there may be more) of a 'Post-Boy', 'Mail-Coachman' and 'Ostler' which Cooper had engraved himself. These are not particularly well done but show that he was now concentrating on those involved in the Road more than the rat-catchers, hot coddlins' sellers, coal tar painters and other street pedlars of previous years. An interesting point of detail in the etching of the 'Post-Boy' (Plate 71) is the metal guard strapped onto his right boot to prevent his leg being bruised by the pole when he was riding a nearside wheeler. The French postillions wore enormous iron boots for the same reason (Plate 8).

There are two lithographs of much better quality than the 'Place de Fiacres' which are not dated but may have been printed during this period: 1827–1830. They are 'The "Age", A Sketch from Castle Square, Brighton' and 'The Park. "'Twas post meridian half past four"'.' Both were published by S. W. Fores. The first is very fine showing the renowned 'Age' Stage Coach at Brighton (Plate 98). The tall coachman standing beside the off-wheeler is Henry Stevenson. In 1827, at the age of twenty-two, Stevenson had graduated at

Cambridge, dissipated a small fortune and was engaged as a coachman by a well-known coach proprietor, Cripps. The following year Stevenson was the owner and coachman of a new coach, the 'Age', which was the smartest vehicle on the London to Brighton road. He died in 1830. Although it is possible that Cooper Henderson painted this scene, as it were, posthumously, this is unlikely. Another print of the 'Age' after a painting by Edward Lambert showing Stevenson on the box at the Bull and Mouth Inn, a London terminal for the Brighton run, was published in 1829, adding weight to dating Cooper's 'Age' in the same period. M. Gauci engraved Cooper's work which was printed by Engelmann Graf Coindet & Co. The use of a professional engraver added much to the distinction of the print, a quality less evident in Cooper's nonetheless lively lithograph of 'The Park' (Plate 97) which he engraved himself. This view of Hyde Park by the statue of Achilles is said to include portraits of the artist, Mr Fitzroy Stanhope, Mr Fores, a Colonel Bridges and Lord Algernon St Maur. Cooper Henderson is in the background (second from the left with mutton chop whiskers) nonchalently sitting astride his hack, hand in pocket, observing the busy scene. The startling dandy on the staring horse must surely be Colonel Bridges! The skyline of passengers and the variety of vehicles show the crush in the Park during the Season with the society of London interested only in showing themselves off and critically examining the competition. Cooper had been signing his work with the familiar C·H·Ɔ monogram for some time, but he introduces it into the picture itself for the first time in the 'Age' on a piece of baggage about to be loaded and on the collar of the mastiff in the foreground of 'The Park'. In the majority of his later paintings of Mails and Coaches this monogram appears on the bags and is not repeated in the usual place for a signature at the foot of the work. The rarity of these two lithographs suggests that few prints were made since S. W. Fores was not yet confident that Cooper Henderson had established himself as a painter of the Road and similar subjects.

As an amateur artist with no need to paint for profit at this stage, Cooper was content to interpret the scenes which amused him, his family or his friends. Perhaps his family found his friends too interested in display, horses and a 'faster' life than they thought proper for Montague Street in the shadow of the British Museum. It may have been too that Cooper's father, still skilfully drawing delightfully tinted landscapes, patronising other artists (Dr Monro had moved to Bushey in 1820), and admiring his elder son's erudition and deep interest in a wide range of antiquarian subjects, was a little exasperated at Cooper's non-conformity and lack of interest in the Law as a profession. His influence over his second son was less obvious than with John, the willing and industrious pupil. There may not have been any such feeling between father and son, but if there was not, Cooper's marriage on Christmas Eve, 1829, at St Andrew Undershaft in the City to Charlotte By, the daughter of Charles William By, a Thames lighterman, must, at least, have proved a difficult situation.

How Cooper met Charlotte is a mystery, but it is possible that she was working as a maid in 3, Montague Street or in a house close by. The difference in age and social position of the pair would have prompted a stormy interview between John Henderson and his son. It is probable too that Cooper's father was not even aware of the marriage until after it had taken

place. Whatever the case, Cooper was given an allowance by his father and told to leave London for a time so starting, if it had not already begun, the tangential course of his life away from the family circle in which he had lived for twenty-six years.

Painting
1830–1850

In early 1830, Cooper and Charlotte went to live at Bracknell, then a small town in Berkshire. Cooper's wife was not quite seventeen years old. He was a determined, resilient and self-possessed young man but the change from the ordered and comfortable life in London with his parents to the necessarily austere circumstances of a small house in the country must have taken time to become used to. Charlotte and he needed considerable confidence to ride out the early weeks and months of their marriage until their first child was born to give their lives a tangible purpose to sustain them. Charles Cooper Jnr was baptised at St Michael the Archangel, Warfield on the 17th of August 1830; his father is described in the Parish Register as a Gentleman living in Bracknell.

The date of this baptism soon after the parents' marriage may point to another reason for John Henderson's disapproval of his son's behaviour as well for the disparity of age and class. Charlotte's father lived in Seething Lane by the Tower. His father and uncles worked in the nearby Customs and his grandfather had held the post of Chief Searcher in the London Custom House but, for Henderson Snr, this was not good enough. Some writers have clutched at the straw of suitability provided by Charles By's cousin, Lieutenant-Colonel John By of the Royal Engineers. He had distinguished himself in the Peninsula War but while Cooper was falling in love with his distant relative, John By was in Canada. Since 1826 he had been designing and supervising the construction of the Rideau Canal, completed in 1832. He also founded Bytown which became the capital of the Dominion of Canada in 1858, when it was renamed Ottawa. Colonel By[1] was a good natured and cheerful man combining great energy with a strict sense of duty for which he was admired and respected. He retired to Frant in Sussex in 1833 with failing health and died there three years later aged 53. By a succession of untimely deaths, a lack of direct heirs and an Act of Parliament, Charlotte became the heiress to large tracts of Ottawa and other land in Canada which had once belonged to the Colonel – but that was thirty years after John Henderson had virtually disinherited his son.

Many local newspapers and journals of the period contain invitations from Mr So-and-so, the well-known animal and figure painter, to take commissions from those who

[1] For an account of the life of Colonel John By and his work in Canada, I am grateful to Mr Robert F. Legget, author of the Historical Society of Ottawa's book: *John By, Builder of the Rideau Canal, Founder of Ottawa.* Published May 1982.

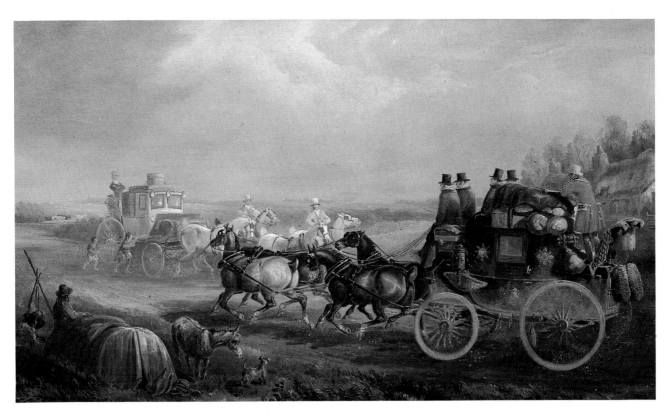

15 Hull-London Royal Mail Meeting a Travelling Chariot on the Road

Oil on canvas, monogram on baggage, 23 × 35 inches. *Private Collection*

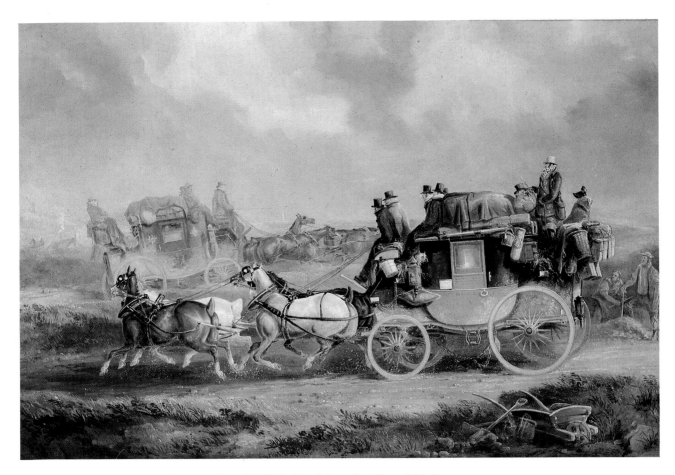

16 The Shrewsbury Wonder Meeting the Holyhead-London Royal Mail

Oil on canvas, monogram on baggage, 24 × 36 inches. *A. Ackermann & Son*

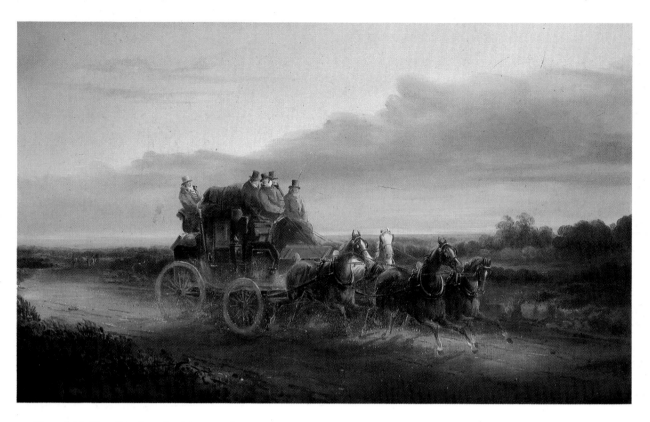

17 **Royal Mail at Daybreak.** Oil on canvas, signed with monogram, 18½ × 30¼ inches

A. Ackermann & Son

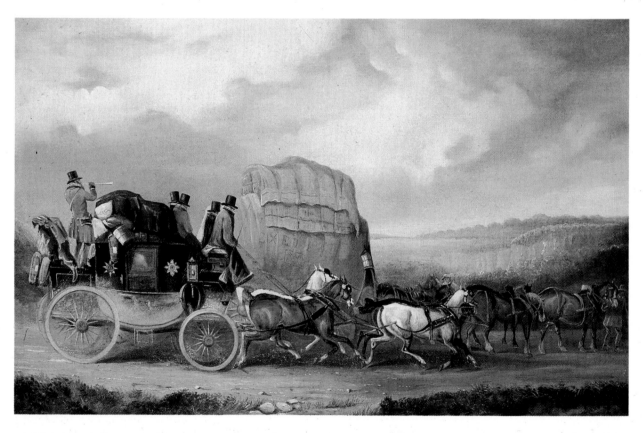

18 **Exeter-London Royal Mail Passing William Downe's Exeter Waggon**

Oil on canvas, monogram on baggage, 18 × 27¾ inches

A. Ackermann & Son

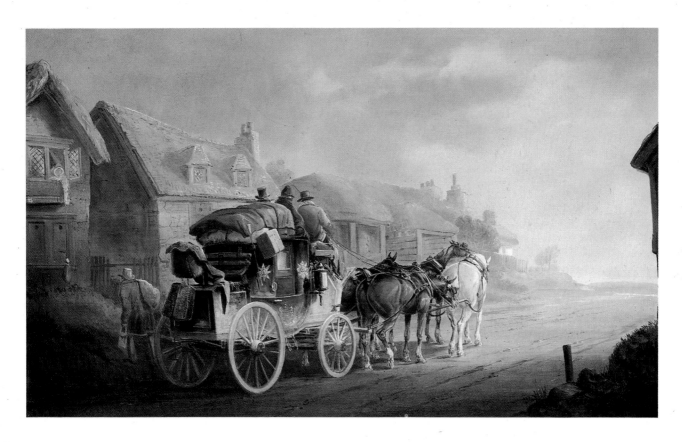

A pair:

19 **Birmingham-London Royal Mail at a Country Post Office.**

Oil on canvas, monogram on parcel, 18 × 30 inches

20 **Royal Mail Through the Toll Gate**. Oil on canvas, signed with monogram, 18 × 30 inches

Richard Green, London

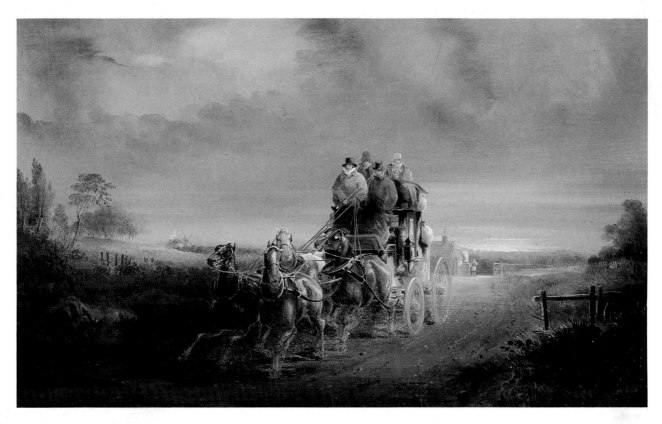

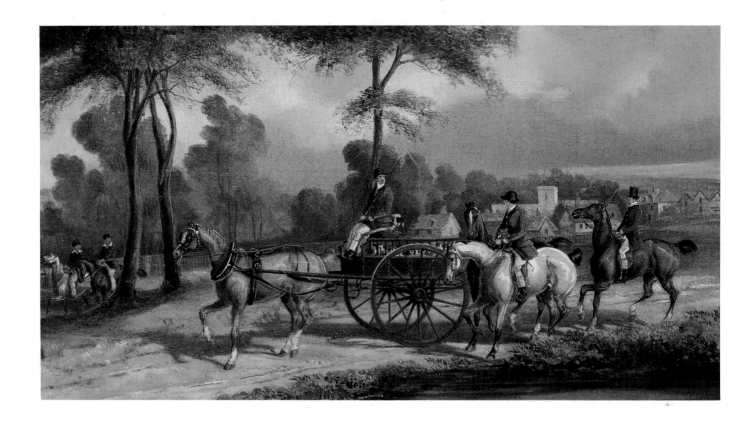

A pair:

21 **Hounds Going to the Meet in a Dog Cart**

22 **Returning from Coursing**

Oils on Canvas, signed with monogram, 12¾ × 23½ inches

Frost & Reed Ltd. These and Plates 53 and 54 form a set of four.

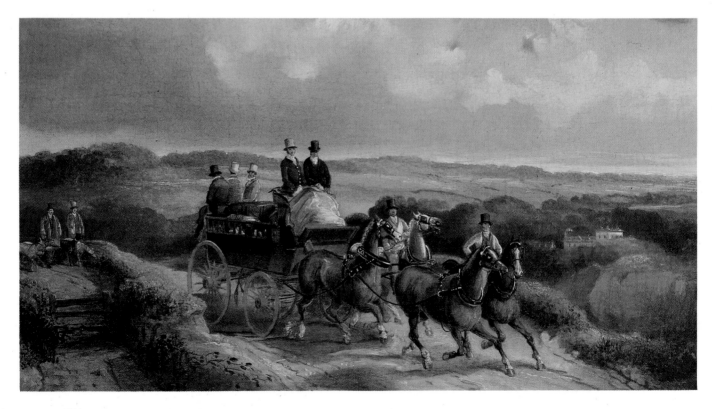

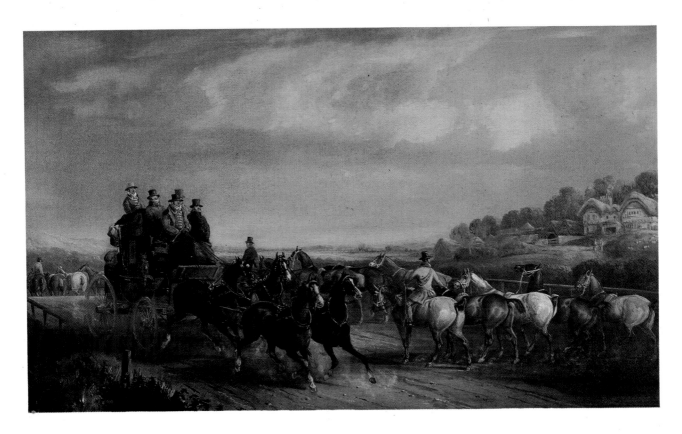

A pair:

23 Royal Mail Meeting Strings of Horses being Taken to a Fair

Oil on canvas, signed with monogram, 18 × 30 inches

24 A French Diligence Passing through a Village

Oil on canvas, signed with monogram, 18 × 30 inches

Private Collection

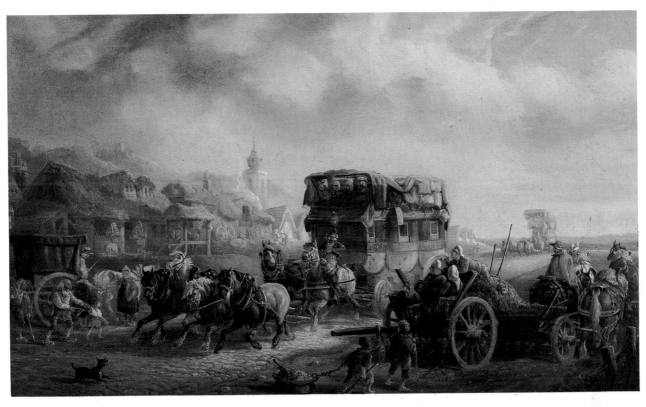

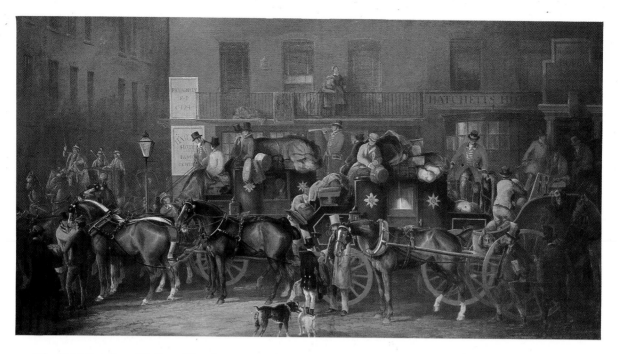

25 The Old Service. Mails at Hatchetts Hotel, Piccadilly, London.

Oil on canvas, monogram on baggage, 32 × 59 inches

Private Collection. See pages 60 and 88

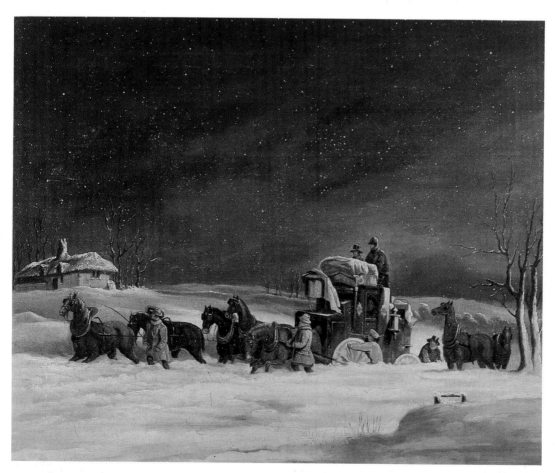

This scene was engraved
by Edward Duncan for
Fores's Coaching Incidents,
Plate II, 'Stuck Fast',
issued on 1 November 1842.

26 Stuck Fast

Oil on canvas, monogram on baggage, 24 × 30 inches

Private Collection. See page 60

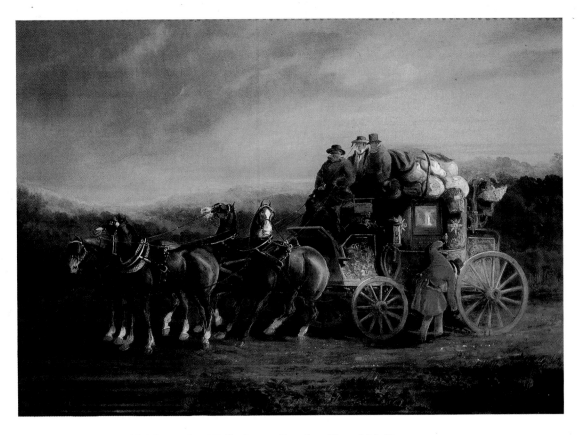

27 Removing the Skid from the Wells-Lynn-London Royal Mail

Oil on canvas, monogram on baggage, 21 × 30 inches. *Williams & Son.*

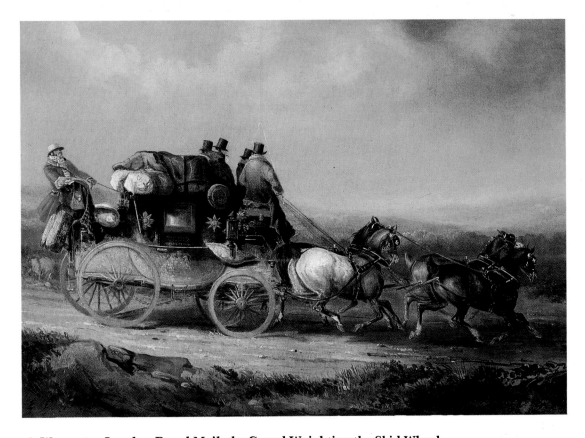

28 Worcester-London Royal Mail, the Guard Weighting the Skid Wheel

Oil on canvas, monogram on baggage, 15 × 22 inches. *Richard Green, London*

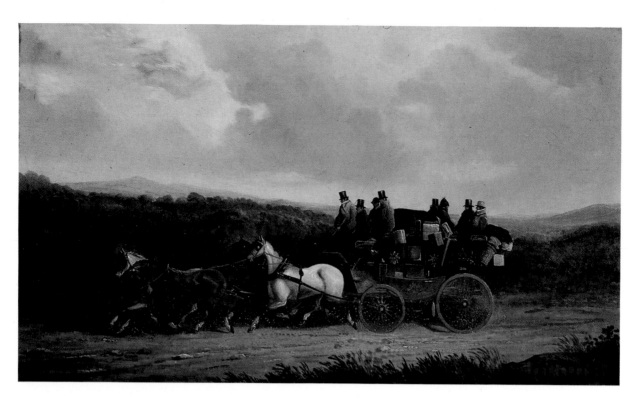

29 Hull-London Royal Mail with Extra Passengers

Oil on canvas, monogram on baggage, 13½ × 23½ inches

Private Collection. See page 71

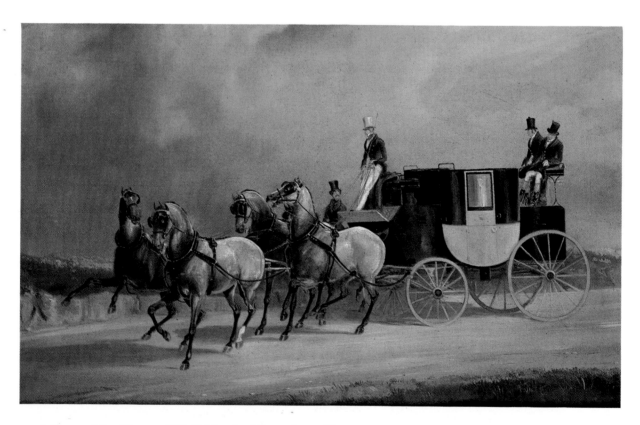

30 A Drag with a Team of Well-Matched Strawberry Roans

Oil on canvas, 16 × 26 inches

Private Collection. See page 74

required their horses, dogs or themselves portrayed. As far as I am aware, Cooper never advertised as an artist, but he was neither a portrait painter nor particularly adept at painting horses in the early 1830s. His friends may have commissioned work, but I believe to start with he painted to amuse himself and experimented in the use of oils, possibly for the first time, as much as to supplement his allowance. He used his sketch books of earlier years to find subjects which he then worked up on millboard and canvas in whatever room of his Bracknell house provided the space and light to be his 'studio'. He was a studio painter throughout his life.

Since Cooper Henderson very rarely dated his work it is impossible, in the absence of any other record, to accurately place his paintings and watercolours in chronological order. The publication dates of engravings provide some guidance, but it does not follow that a print was made immediately a painting was finished; it may have been engraved some years later. A rough and ready measure of chronology of pictures of Mails is the royal cipher, but the GRs, WR and VR are often obscured by mud, the whirring wheels or flying dust making them indecipherable. Even when these ornately painted letters can be seen, the mail may have been painted retrospectively as was much of Cooper's work. One therefore falls back on style to 'date' his pictures, or place together a number of similar paintings as being earlier or later than another group.

The first group is characterised by a large proportion of the canvas being covered by the principle subject matter with little room for sky or depth of foreground – the 'close-up' picture. This, with the coarseness of the brushstrokes and a surprising feature, the painting of horses' eyes expressing human emotion (like a Landseer' hound), are the criteria for this early group. The crude painting of the horses' flanks and the imprecision of the clothes of the otherwise well-modelled figures in the two small paintings (9 × 13 inches) of 'The Halt' (Plate 40) and the 'Continental Village Scene' (Plate 41) suggest that they are among Cooper's first essays in oils. The slightly larger paintings of the 'Calais Mail at Speed' (Plate 42) and the 'Post-Chaise about to Depart' (Plate 43) are vigorous and full of movement with the team of the French coach pounding the road as fiercely as any depicted by Gericault, their eyes showing more white and more expression than in reality. There is much of interest in the picture of the Yellow Bounder: the ostler handing a note to the post-boy to deliver; the knee-breeched butler opening the coronetted door; the hanging bacon and game; and the cat rubbing its side, as cats do, against the spike-topped doors making the off-wheeler nervous. The whole scene shows a confident familiarity, albeit painted from memory. Two more early paintings of the same size, repeating what was to become a favourite theme of coaching at home and coaching abroad, are the pair: 'The Hackney Stand' (Plate 7) and 'Loading the Diligence' (Plate 8). The first is best described by Dickens in Sketches by 'Boz':

'A great, lumbering, square concern, of a dingy yellow character (like a bilious brunette), with very small glasses and very large frames. The panels are ornamented with a faded coat-of-arms, in shape something like a dissected bat.'

and 'Jehu' writing in the *London Magazine* in 1825:

'A hackney coach – fogh! Who can be a gentleman and visit in a hackney coach? Who can, indeed? To predicate nothing of stinking wet straw and broken windows, and cushions on which the last dandy has cleaned his shoes, and of the last fever it has carried to Guy's, or the last load of convicts to the hulks.'

The whole picture needs close study, each part has a tale to tell of London life, and note the startled eye of the near-side chestnut. 'Loading the Diligence' is just as rewarding in its detail. The vast cumbersome coaches are being loaded in what appears to be a disused church, perhaps ransacked at the time of the Revolution. The postillion's iron boots worn to prevent his leg being damaged by the jaundice-eyed off-wheeler stand ready to be pulled on, while basket is piled on basket and covered with a giant tarpaulin. (As a short cut, Cooper has painted the same horses for each picture but reversed their positions.) Like a square-rigged ship sailing before the wind, the diligence will creakingly pull out of the church to pick up its ten or twenty passengers before lurching slowly along the French roads groaning at every rut and stone its heavy wheels encounter. These are a few of Cooper Henderson's early efforts where he is still experimenting, producing what some would describe as oil sketches rather than finished paintings.

In 1830 and 1834, Rudolph Ackermann had published aquatint plates after Cooper Henderson's work. The first was 'A French Diligence', followed by a pair: 'English Post-Boys' (Plate 73) and 'French Postilions' (Plate 74). This association with Ackermann prompted the realisation to Cooper that he could only substantially increase his income by being close to London, nearer to the print publishers and patrons who might give him commissions. Bracknell was too remote from the metropolis. He was being forgotten by those who had recognised his talent in the past and perhaps the pain to his parents of his precipitous marriage was subsiding. His brother John plainly had little intention of marrying, his sisters were spinsters passing a marriageable age, and it is probable that his mother, at least, longed to see her grandchildren more often and more easily. Cooper moved his growing family to 40 Edwardes Square in 1836. The Square comprised brick terraces of reticent style built in the early 1820s across the turnpike (now Kensington High Street) from the old south gate of Holland Park.

Once close to London, Cooper realised too that the most popular paintings of the Road, a theme with which he had only dabbled so far, were of the Mails and Coaches already approaching the end of their Golden Age, soon to be eclipsed by the railway. James Pollard's pictures and engravings with their slightly naive style were to be seen in the picture dealers' and print publishers' windows. A few other artists painted coaches as the subject of their compositions and many included them as incidental to a landscape or town scene to give their work life, but Pollard was pre-eminent. The public received such pictures with enthusiasm being more appreciative of the past than the uncertain present or future. Although Cooper continued to paint a few pictures of continental scenes, often paired with coaching at home, he quickly turned his attention to the English coach and other horse-drawn vehicles. He took more care in composition and stepped back, as it were, to paint extensive landscape settings for his Mails, gigs, wagonettes, chaises and phaetons. He started to tighten his brushwork, take care with moulding the muscles and sinews of his horses and concentrate on accurately portraying the speed of the vehicle and movement of

its team, the last so deficient in Pollard's work. As well as having a quick eye for the detail of coaching and driving, he must have had some personal experience with the ribbons to be able to satisfy the connoisseurs of the Road that every detail was correct. They would have been quick to criticise if it was otherwise.

'The Night Team' (Plate 9) and 'Day Stage' (Plate 10) can be dated at the beginning of the second period or grouping of his work. Both pictures still contain some looseness of brushwork but the composition is more assured and what might be called the distractions of the earlier paintings such as the dogs, cats and wayside peasants have been banished. He was fascinated by the Road at night and exactly catches the intimate atmosphere of a lamplit coach passing through the slumbering countryside on its own special business with only the moon for company. There were the conditions of the elements to portray as well. Many of his daytime scenes enjoy fine weather, but he became equally skilled in painting wind and rainswept coaches with their passengers huddled forward longing for the short respite of the next change of horses or the longer stop for breakfast or supper in a warm and friendly inn. His evening and early morning skies are finely painted foretelling a long night ahead or the welcoming first rays of sunlight to take away the chill of frost which the outside passengers have endured.

At Christmas 1836, a month after a third son, Kennett Gregg, was born on the 27th of November, there was a snowstorm of such ferocity and duration that the whole country was completely disrupted. This did not worry Mr Jorrocks too much. Having hung out 'a flag of distress – a red wipe', he had to be manhandled out of an upstairs window of the inn at which he was staying in Brighton. He reported:

'The storm stopped all wisiting, and even the Countess of Winterton's ball was obliged to be put off. Howsomever, that did not interfere at all with Jonathan Boxall and me, except that it perhaps made us take a bottom of brandy more than usual. . . .'

The Mails came to an almost complete stop and the experiences of the coachman and guard of the Devonport Mail were typical of many others. Having driven into the face of the storm for a number of hours the coach became stuck fast. The horses were nearly buried and the coachman jumped down from his box into a drift and disappeared from sight. The guard who was at the lead horse's head had great difficulty in getting to him to dig him out. Farmers willingly turned out to rescue the snowbound coaches and their occupants. They were not always completely successful. When the waggon horses were put to the Chester Mail on Hockley Hill near Dunstable to pull it out of a drift, the fore axle gave way and left the coach behind. The lack of preparedness for the snow was more understandable then than now. However, even the least cynical must have smiled at the timing of the Secretary of the Post Office who published a diagram of how to make a snow plough on the last day of the year when most of the roads were passable. The plough itself was a triangular affair of wood with a metal bow. It was to be drawn by two or more waggon horses, but its design suggests that at best it would have made a good sleigh. Ten years later, in Pencillings in the Provinces, 'Whiz' of the Sporting Magazine recalls this snowstorm and acknowledge's Cooper's ability to paint a snowbound coach. Whiz is on the Exeter Mail out of London and,

leaving Andover in heavy snow, the coach finally comes to a stop a short way from Wallop, the next place for a change of horses.

> 'Crack goes the whip, but the flesh is weak; the steel is gone, the good little galloping team had come to a standstill. "Blow your horn, Churchill," hollas the coachman; "they will mind that – they are near home;" but the horn only mocks their endeavours as they paw and struggle, for they are up to their bellies in snow. Oh Henderson, you must have been with us, or you never could have delineated the mail in difficulty.'

In 'Stuck Fast' (Plate 26) three farm horses have been added to a pair of the Chester Mail to try to drag the coach out backwards, but with little success – the inside passengers sit tight! The guard may be deciding to mount the fittest looking leader to take the mail bags on, his first duty and more a matter of Post Office honour than the actual urgency of the letters. This painting, and many similar pictures, was probably inspired by the stories which circulated about the often heroic efforts of the coachmen and guards to keep the Mails and Coaches running during 'The Snow Storm' as *The Times* titled its reports of the events of Christmas 1836. It is likely, therefore, that all the snow scenes which Cooper painted can be dated as after that year. James Pollard does not appear to have painted any pictures of snowbound coaches before 1836.

Cooper's landscape settings are sometimes slight but can show picturesque villages with thatched cottages, distant spires and wooded hills. A few can be identified: below the cliffs near Dover; on Lancaster sands; Shap Fell and elsewhere. Excepting a very few later *tours de force* such as 'The Old Service' (in Piccadilly) (Plate 25), Cooper rarely painted townscapes, possibly for the simple reason that in them the coaches were necessarily slow-moving or static; this he found dull work having so completely mastered coaches at speed. These rare paintings of the metropolis or county towns were probably commissioned to provide an evocation of earlier days. The majority fall into the last period of his painting in which his technique is as finished as the work of his better known 'professional' contemporaries such as J. F. Herring (1795–1865) and W. J. Shayer (1811–1892).

In 1837 and 1839, Ackermann published more aquatints after Cooper Henderson's pictures of which 'The Taglioni!!! (Windsor Coach at Full Speed)', (Plate 75) is the best. Devoid of setting, except a line for the road, the speed of the coach and the actions of the horses pulling it are accentuated by the lack of unnecessary fuss or detail. One can almost hear the whole ensemble humming along like a finely tuned machine. John Harris engraved this plate from a watercolour similar to the 'Oxford Coach' (Plate 36) in which the deftness of Cooper's brushwork is outstanding. Harris (1811–1865) served Cooper and a host of other topographical, sporting and military artists extremely well. The son of a cabinet maker, he followed the engraver's craft all his life, not graduating, as did many other aquatintists, to painting in oils or watercolour himself. He was a faithful interpreter of original work in any medium and must have floated the acid over nearly a thousand copper plates in his lifetime. He worked for all the principal print publishers for not much reward before becoming almost blind and dying a poor man. He lies without monument in Highgate Cemetery.

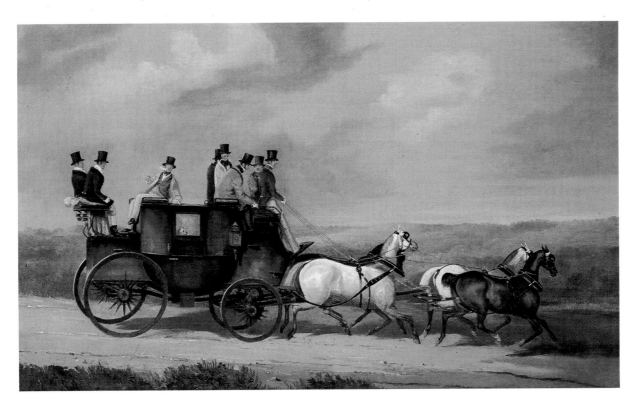

31. **An Afternoon Jaunt in a Drag.** Oil on canvas, 18 × 30 inches

Private Collection. See page 74

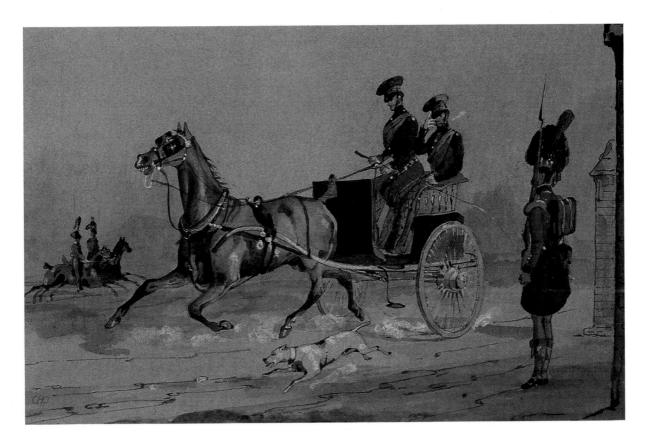

32 **The Barrack Gate.** Watercolour, signed with monogram, 6½ × 10 inches

Two officers fly past the Black Watch sentry in their handy gig.

Private Collection

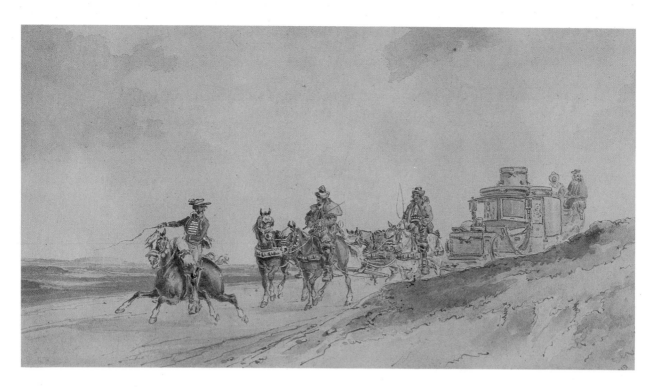

33 **A Courier Leading a Travelling Chariot**. Watercolour, signed with monogram, 8 × 14½ inches

Private Collection. See page 40

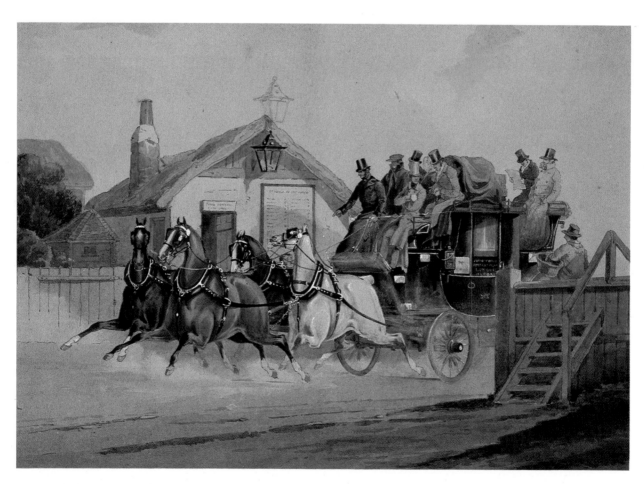

34 **Oxford-London Coach Going through a Turnpike Gate.** Watercolour, signed with monogram, 10½ × 14½ inches

Private Collection

35 French Fisherfolk on the Beach at Dunkirk

Watercolour on grey paper,
signed with monogram, 5 × 7½ inches

Private Collection. See page 73

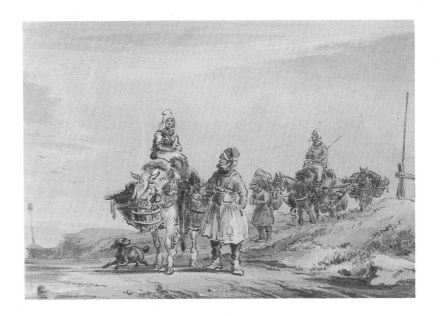

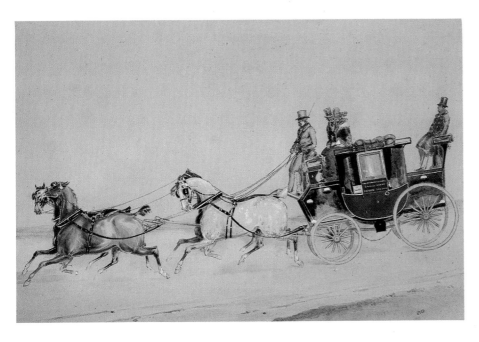

A pair:

36 Oxford Coach at Speed

37 Brighton Coach Waiting to Go

Watercolours, signed with monogram.
13½ × 20 inches

Private Collection. See page 60

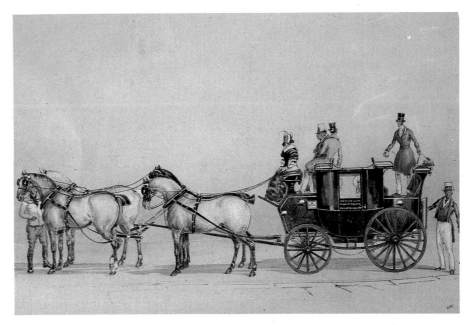

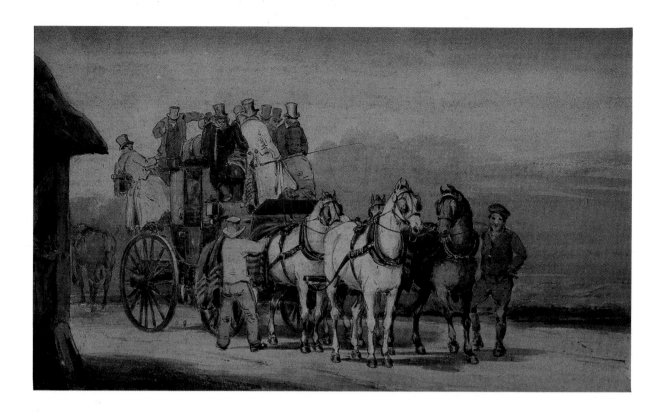

A pair:

38 **Ready to Go**

39 **A French Diligence**

Watercolours, signed with monogram, 10½ × 17½ inches

Private Collection

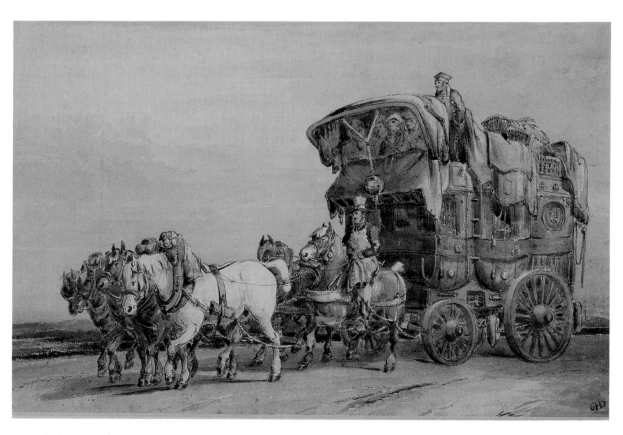

Cooper moved house again after a fourth son, Robert, was born in August 1838. No 40 Edwardes Square was beginning to be too small for his family and 3 Lamb's Conduit Place, their new home in the shadow of the Foundling Hospital, provided more accommodation. The Hospital had been founded a hundred years earlier and by 1840 housed a remarkable collection of paintings by the best English artists of the eighteenth century. Led by Hogarth, they had ornamented its walls as a means of displaying their work. The enclave of six houses forming the Place, long since demolished, at the north end of Lamb's Conduit Street, remained their home for the next ten years. Cooper employed five female servants at this time showing, perhaps, that he was not too short of funds. He was also nearer to his parents, brother and sisters in Montague Street and it would be good to think that any rift between Cooper and his father had been bridged and the family was united, accepting Charlotte as one of them.

From 1839 to 1843 the *Sporting Review* and the *New Sporting Magazine* carried engravings after Cooper's work on a number of occasions. These were predominantly scenes of the Road but 'The Earth Stopper' engraved by T. A. Prior in the *Sporting Review* of November 1839 is out of the ordinary. It is a haunting moonlight scene of the hunt servant with his pony, terrier, pick, spade and lantern on his cold early morning task. Another plate, 'The Berkeley Hunt', which Captain Frank Siltzer in *The Story of British Sporting Prints* mistakenly took to be a 'departure from his usual choice of subject' is, in fact, typical of Cooper's first love since the title is the name of a Cheltenham-London Stage Coach. One plate in 'Nimrod's Hunting Reminiscences' published in 1843 of 'The Cover Side' is out of the ordinary for Cooper Henderson. It shows three riders at a gate by a copse, one holding it open for his companions to pass through. The background is a wooded hill with other riders and hounds hunting. These plates must have been valuable in bringing Cooper's name to the attention of patrons among the wide readership of these two monthly magazines and this classic book.

Cooper had his first painting exhibited at the Royal Academy in 1840. It was of 'The Edinburgh and Glasgow Mails Parting Company' (Plate 49). This is a large picture typical of the skill which he had by then achieved in balancing the vigour of his brush with a smooth technique. The sides of the horses shine and sweat, the laden mails bowl along and the composition of the foreground coach running downhill and the distant Glasgow Mail climbing to the right is cleverly shown.

N. Calvert of Wakefield Street, Regent Square published a portfolio of Cooper's own etchings titled 'Road Scrapings' in 1840 and 1841. These small, entertaining plates with a central subject surrounded by a number of smaller scenes came straight from his sketch-books. There are six sheets of home vignettes and six of the Continent. Each one (Plate 78) is full of action and from them one can recognise parts of oil paintings and watercolours where a figure, cart, coach or a whole scene has been repeated. Messrs Fores bought the plates at some point and republished the set adding their name to the existing title at the foot of each etching and changing, but not dating, the publication line. This may have been done some years after Cooper re-established his connection with the firm in 1841, forsaking Ackermann. On the 1st of January 1842, Fores published the first two plates of 'Coaching Recollections' after Cooper's paintings, one still in his possession and the other belonging to

Lord Macdonald. During the next few years Fores published, concurrently, more plates for their Recollections; their 'Road Scenes' showing hunters, hacks and farm horses 'Going to a Fair'; 'Coaching Incidents' for which Cooper was commissioned by the firm to paint the pictures; and 'Sporting Traps'. These eighteen fine aquatints, the majority engraved by Harris, were published between 1842 and 1848, and a number were produced in parallel by French publishers in Paris. The 'Coaching Recollections' and 'Coaching Incidents' are among the best known sets of Road scenes of the period and of today. They finally established Cooper's name as the master of this kind of painting. For the connoisseur of coaching practice and detail, he outshone James Pollard although the latter's work is exceptionally decorative and of considerable importance historically from the many identifiable settings of his Mails and Coaches, but less convincing teams. Like many artists, Cooper painted a number of versions of much the same scene. A painting titled 'The Descent from High Hesket to Penrith of the Edinburgh-London Royal Mail Coach' is very similar to the 'Gloucester-Hereford-Carmarthen-Aberystwyth Royal Mail', the original for 'Pulling Up to Unskid' in 'Fores's Coaching Recollections'. Equally, there are many paintings from which Harris could have engraved 'All Right' in the same series. Not only did this practice of repeating similar themes open the way for some bad attributions to his hand, but the full-size engravings have allowed copyists to imitate his work with considerable ease; even to the extent of including his monogram on the baggage of a loaded coach. He also undertook a number of hunting pictures as well as the familiar Road scenes of wagonettes, gigs and dog-carts of all descriptions with sportsmen going out or returning from a day in the country. The best of these are in watercolour. He painted a few equine portraits but they were rarely successful. Like paintings of street scenes, he may have found it difficult to give life to the static animal. The vitality and latent power cannot be found on these canvases. The only good portraits of horses were those used for heavy work such as the 'Quarry Percherons' in Plates 57 and 58. These solid, dignified animals stand four-square and as immovable as the immense blocks of stone that they had to pull. They are caparisoned in their special harness and Cooper enjoyed painting this as much as the horses themselves.

Mary Henderson was born in January 1840 and Roderick William in 1841, but then three deaths occurred which affected but did not significantly change Cooper's and Charlotte's lives. In March 1842 the three-and-a-half years old Robert died of a disease of the brain, possibly sustained at birth. Cooper's father died in December 1843 and a year later, in February 1845, his sister Harriet, in a fit of insanity, threw herself over the bannisters of a flight of stairs in Montague Street and was killed.

John Henderson Snr, after providing a small annuity for his wife 'limited to this amount as a token of regard and on account of her being amply provided for otherwise than by this Will', left everything to Cooper's elder brother John. 'I declare,' their father wrote, 'I have omitted bequests to my younger son Cooper and my two daughters Georgiana and Harriet in consequence of having otherwise provided for them.' He was probably also aware that his wife intended to leave her 'ample' inheritance equally between the children who survived her.

In the last years of the 1840s, Cooper continued to paint a variety of subjects. By this

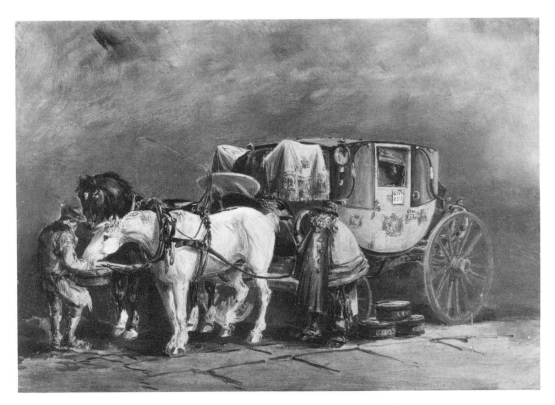

40 **The Halt,** Oil on millboard, monograms on water buckets, 9 × 12¾ inches

William Drummond. See page 57

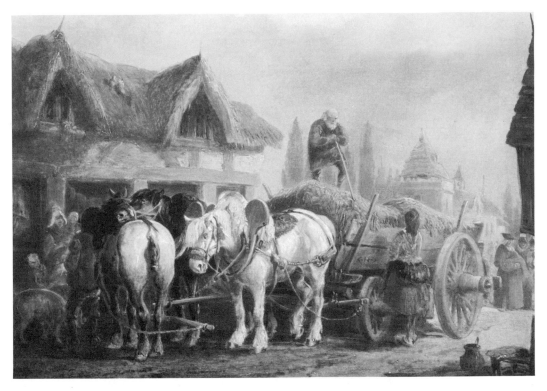

41 **Continental Village Scene** Oil on millboard, signed with monogram (twice) 9 × 13 inches.

Pawsey & Payne. See page 57

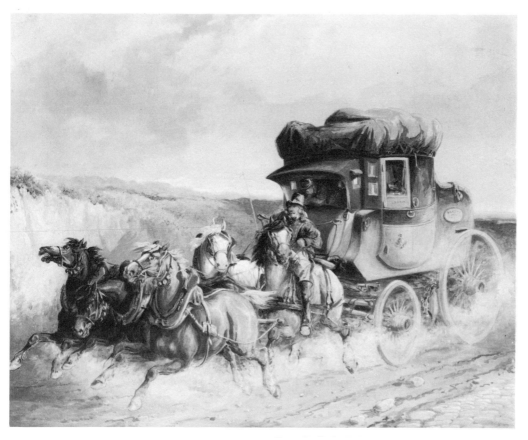

42 **Calais Mail at Speed.** Oil on canvas, 16½ × 20¾ inches

Sotheby's. See page 57

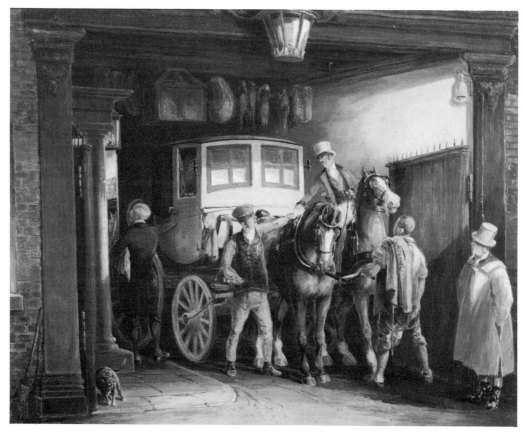

43 **Post-Chaise about to Depart.** Oil on canvas, signed with monogram 16½ × 20¾ inches

Sotheby's. See page 57

A set of four:

Oils on millboard, signed with monograms,
8 × 12 inches

A. Ackermann & Son

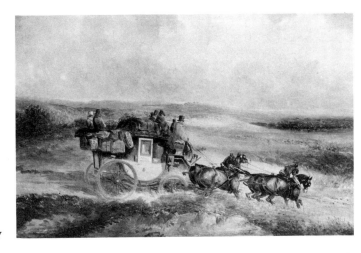

44 **A Stage Coach
in Open Country**

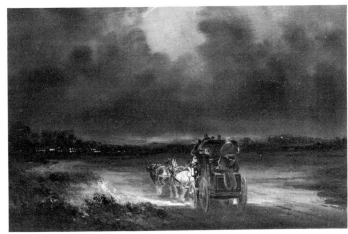

45 **Approaching a Village
at Night**

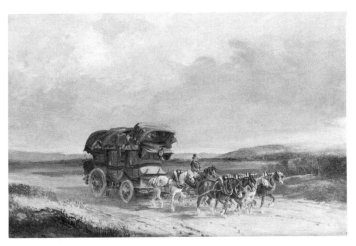

46 **A French Diligence**

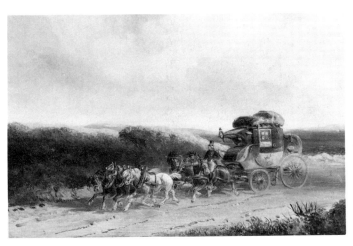

47 **A Malle Poste.** See page 33

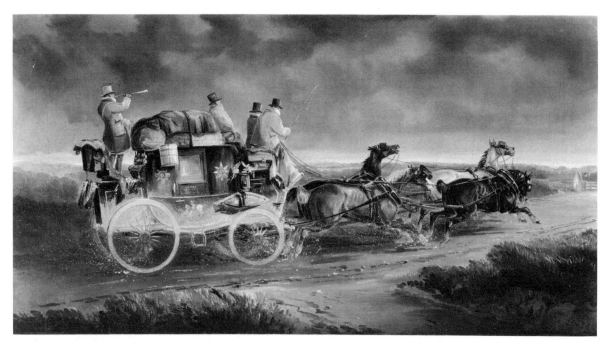

48 The Guard of the Dover-London Royal Mail Warning the Gatekeeper

Oil on canvas, monogram on baggage, 12½ × 23½ inches. *Richard Green, London.* See page 27

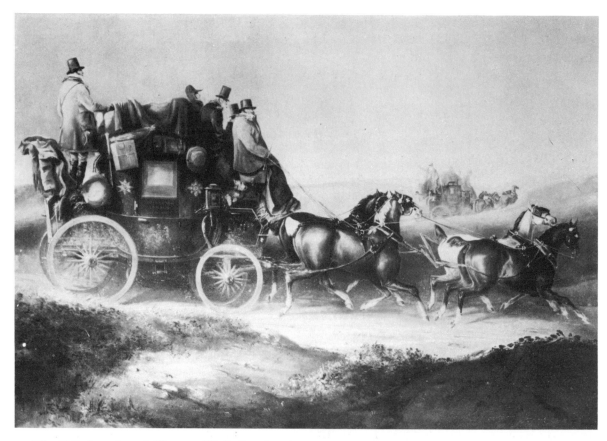

49 The Edinburgh and Glasgow Mails Parting Company

Oil on canvas, monogram on baggage, 24 × 35 inches. *Christie's.* See page 65

time much of his work was commissioned and, when painting coaches, his patrons were trying to recapture the halcyon days of the Road. However it should not be thought that Mails and Coaches had all disappeared at the first puff of steam. Although the Stockton and Darlington Railway had opened twenty years before, the great railway boom which finally drove the long distance coaches off the roads was not until 1845 to 1848. The annual expenditure on railways before 1844 had been £5m but rose to £185m in 1844–46, and while there were only 2000 miles of track in 1843 this had more than doubled to 5000 by 1848. Many of the smaller railway companies who owned short stretches of local lines were combining during the period reducing their number from 200 in 1846 to a mere 22 in 1851. Also the advantages of rail travel were slow to be accepted by the poorer members of the public until the Cheap Trains Act of 1844 provided a sharp increase in passenger traffic. The Act required that every line must run a train each way daily at a speed of not less than 12 mph and at a charge to passengers, who had to be carried in covered waggons, of not more than one penny a mile. Stage coaches continued to run between those towns not served by the railway and there were cross-country mail services as well. There is evidence that the earlier strict regulations regarding passengers not travelling at the back of the Mails were relaxed. Stanley Harris in a footnote to his book, *The Coaching Age*, states that the Dover day Mail, as also the Brighton, used to carry passengers behind on a seat facing the guard. There were occasions too when the contractors owning the coaches persuaded the Post Office to allow them to carry more passengers outside to make the contract worthwhile and reduce the charges on the Post Office for carrying the mail. Henderson's painting illustrated at Plate 29 shows what must have been, if it was not still, a Mail which, being released from the Post Office contract in consequence of the railways carrying the mail, is being used as a Stage. The guard's single perch at the rear has been replaced by a double seat and the coach carries a licence plate. It is probable that the proprietor felt justified in keeping most of the Mail's livery in memory of its former glory.

Cooper's picture of the 'Diligence of 1830' was exhibited at the Royal Academy in 1848 and it was in the last years of the 1840s that Cooper's painting became wholly retrospective. This suited him. Apart from his sketches which he made in the open air, he painted indoors in his studio or wherever he found elbow-room out of reach of his children. For the most part he painted the broadside view of coaches and continued to illustrate with great accuracy the various mechanics of driving with tight or loose reins, giving the teams their heads, pulling up to put on the skid or remove it with the weight of the coach on the collars of the wheelers, or dealing with an awkward horse. There was some repetition with the actions of the trotting and galloping teams for one coach being much the same as for another, but the result was always lively, realistic and pleasing. The monogram could be copied easily, as it certainly has been, but once Cooper's style of painting horses is recognised this provides the most reliable 'signature' of his work.

Towards the end of 1849 Cooper Henderson realised that his mother's life was drawing to a close and he would soon be able to retire, move from London and give up a way of life he had adopted for the past twenty years. Georgiana Henderson died on the 8th of January 1850. A small part of the Keate Estate in Spitalfields had been sold some time before but the

main portion remained intact which, together with all else that she possessed, was shared equally between her sons, John and Cooper, and her daughter Georgiana giving each a considerable income. Georgiana kept house in Montague Street for her scholarly bachelor brother. Cooper escaped to the country to live in some style at Lower Halliford-on-Thames, Surrey.

Cooper's painting career, starting in 1830, was short but fortunately well timed. To begin with he may not have realised he could supplement his private income by painting the Open Road. By 1836 capitalising on his quickly improving skill with oils he knew that he must be close to the metropolis to achieve real success. Even in London those interested in sporting painting were few and, paradoxically, lived most of the year in the country only coming to town for the Season. Until the 1820s these patrons of the sporting artists had to travel slowly in a variety of heavy carriages over very poor roads, but the excitement of the speed which the improvement of both allowed gave a glamour which they thought should be recorded. It was at this time that Cooper presented himself to so successfully capture these scenes for a brief period – the timing was accidently perfect.

Retirement
1850–1877

Cooper Henderson leased a hip-roofed eighteenth-century house on the north bank of the Thames at Lower Halliford-on-Thames between Shepperton and Walton. Known as Halliford Bend, the house can be seen across the river in the painting by Charles Cooper Henderson Jnr (Plate 5). His father is sitting in the punt with his back to his son who may have thought that to attempt to portray his face was too difficult. Part of the house can still be seen swamped by additions which are so completely out of harmony that it is difficult to visualise the once fine original façade between the gable-end chimney-tops (Plate 6). Behind the old house in Cooper's day there was a cottage, stabling, a yard and garden with fields stretching away to the north almost as far as the eye could see. The bend in the river, which the house faces over a small garden, would have been a tranquil place where Cooper may have crossed for picnics with his children in the lush tree-lined meadows opposite.

Cooper's establishment at Halliford comprised a governess, nurse, cook, housemaid, coachman and indoor servant to look after his family which included six children still living at home. Charles Cooper Jnr who had been educated at University College School in London had left to practise dentistry and the second son, John, was about to enter the Army. Apart from his eldest son, the children do not seem to have shown any interest or aptitude in painting which may have been a disappointment to Cooper, but at this period he painted very little himself, almost giving up oils and only dabbling in watercolour for amusement. However, one can be sure that he taught his children the rudiments of drawing, an essential accomplishment for his daughters and a useful skill for the two boys who became Army officers. There were frequent visits to France from which the children became fluent in the language and learnt to love the country as much as their father. Cooper's work was admired by French critics of coaching which, with the publication of a number of his engraved works in Paris, may have provided useful entrées into the houses of Frenchmen with tastes similar to his own. His small watercolours of French fisherfolk are numerous. They were usually drawn on grey or light blue paper, heightened with white, and dwelt on the sturdy figures of peasants, their ponies and poodles (Plate 35). Many of these little sketches were painted after 1850 when he had almost given up using oils.

Although no longer painting the Road, Cooper retained his interest in coaching and driving. He became one of a small group of gentlemen calling themselves The Critics who,

during the London Season, commented upon the fashionable turn-outs in Hyde Park. Cooper himself drove a yellow mail phaeton with a matched pair of roans rivalling his old patron, the Earl of Chesterfield, who was said to drive the smartest phaeton in town. In the early 1850s there were not many private four-in-hand coaches or 'Drags' as they were known. At the beginning of the century there had been three clubs for those practising driving and amateur coachmanship, but these had languished at the time of the demise of first the Mails and then the Coaches. In 1856 the Four-in-Hand Club was formed, presided over by the Duke of Beaufort, and a decade later there was a revival with 'Old Times' Coaches being driven to a regular timetable on the London to Brighton road. At the first meeting of The Coaching Club on the 27th of June 1871, twenty-two coaches mustered at Marble Arch, many of them Drags. The Drag was an elegant vehicle which Cooper often painted. In Plate 30 a gentleman is training his smart team of strawberry roans in the country – an acquaintance is possibly giving some gratuitous advice and the driver wishes he would be on his way so that he could continue his exercise in peace. Six other gentlemen are intent on having a jolly afternoon in Plate 31, only the inside passenger looks a little glum!

Time would have passed in a congenial fashion for Cooper, travelling, staying with friends, visiting London or being quietly at home to supervise his childrens' education. There is evidence that he embarked on drawing a few shorescapes in a quite different style to his small watercolours of the French coast. There are two very large watercolours of Lymington harbour being built which were probably painted on the spot, a departure from his usual studio work. Both employ a free brush with shipping beneath a cloud-strewn sky. They are unsigned but the faces of the fishermen and stonemasons are unmistakably his and, like the drawing of his horses, a better signature than any number of monograms. This pleasant life ended in 1858.

Charlotte died of cancer in London on the 31st of May. She had been ill for two years. The inauspicious start to their marriage had bound them together with an extra strength. Charlotte had been a loving wife and dear mother to the nine children she bore Cooper. She was interred in that strange and eerie resting place, the Catacombs at Kensall Green Cemetery. There she joined her infant son Robert, John Henderson her father-in-law, Georgiana his wife and the fatally insane Harriet. Charlotte was forty-five when she died and Cooper was desolate without her companionship and love. The older children had left home and could provide little comfort. Charles Cooper Jnr was working in Southampton, John and Kennett were with their regiments in Bengal fighting in the Mutiny campaign, and the two youngest boys, George and Henry, had been sent to Westminster School when their mother became too ill to look after them. Also, Cooper had never really known Charlotte's family. In 1858 her parents were living with their daughter Maria (one of Charlotte's two sisters who were the only witnesses at her wedding), the wife of Henry Holmes, a Clerk in London docks. Cooper's daughter, Charlotte, managed the suddenly too large house at Halliford Bend but the void in his life left by the untimely death of his wife took long to fill and he never fully recovered from the blow.

A revival in the popularity of Cooper's paintings and, in particular, the engravings after

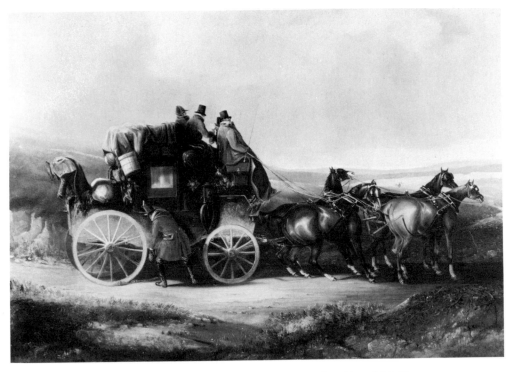

50 Guard Removing the Skid from the Glasgow-London Royal Mail

Oil on canvas, monogram on baggage, 24½ × 36 inches. *Christie's*

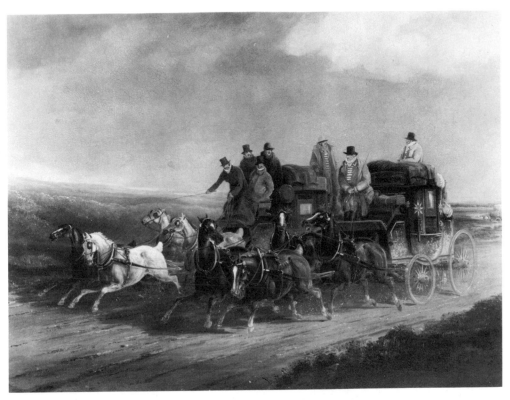

51 Edinburgh-London Royal Mail Overtaking another Mail

Oil on canvas, monogram on baggage, 24 × 36 inches. *The Leger Galleries Ltd.*

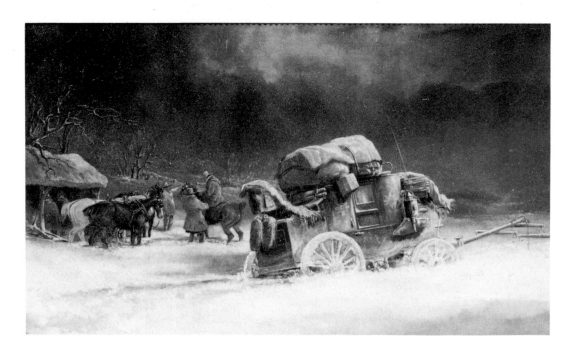

52 **Edinburgh-
London Royal
Mail Snowbound
at a Way Station**

Oil on canvas,
monogram on baggage,
18½ × 30 inches

Sotheby's

A pair;

Oils on canvas,
signed with monogram,
12¾ × 23½ inches

A. Ackermann & Son

These and Plates 21
and 22 make a set of
four

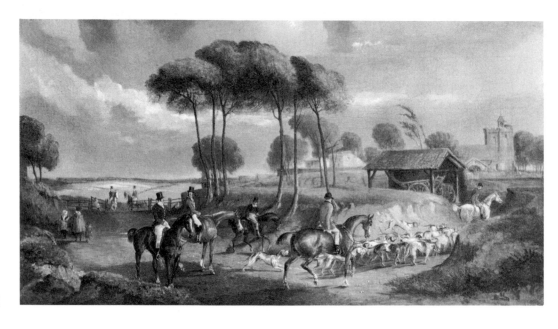

53 **Cub Hunting**

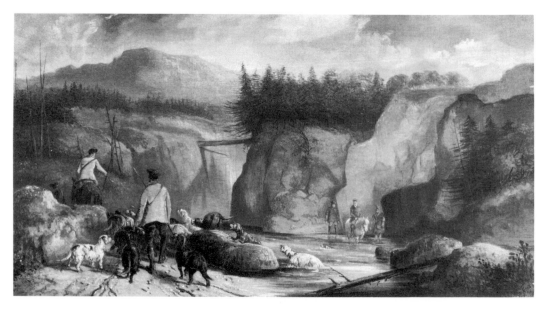

54 **Otter Hunting
in Scotland**

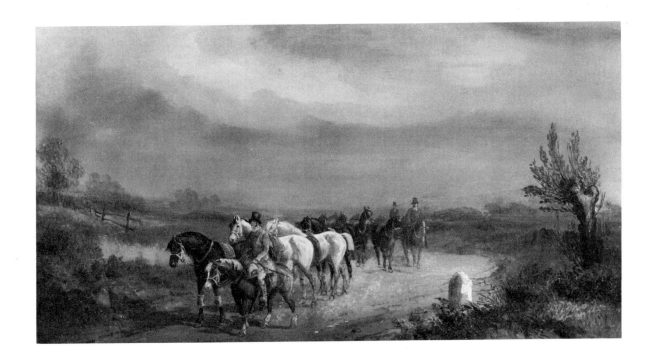

A pair:

55 Hunter and Hacks on a Country Road

56 Farm Horses Going to a Fair

Oils on canvas, signed with monogram, 13 × 24 inches

A. Ackermann & Son

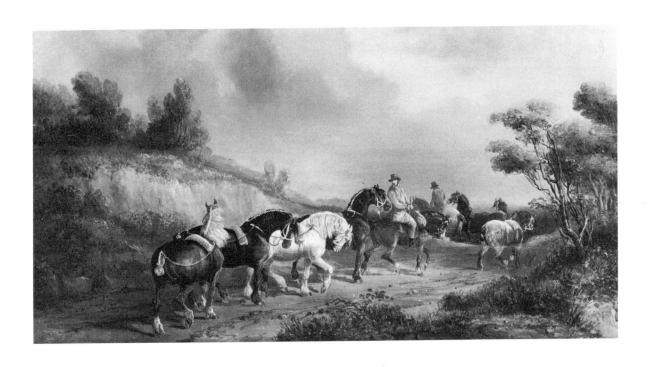

A pair:

57 **A Chestnut Quarry Percheron**

58 **A Grey Quarry Percheron**
Oils on canvas, signed with monograms. *Private Collection.* See page 66

his work went hand in hand with the renewed interest and enthusiasm for coaching during the late 1860s and early 1870s. The sporting magazines published occasional steel plates from his watercolours and oils and in January 1874 Fores published new 'Coaching Recollections' engraved by Henry Papprill (1816–c1890). This set comprised the scenes of Plates I to V of the old series in a smaller format. Although Papprill engraved in more detail, as was the fashion at the end of the nineteenth century, the crispness of his etching and the fine ground of the aquatint led to lively prints faithful to the original paintings. Cooper's name was therefore kept in the public eye despite the fact that he was becoming less and less active with the brush.

The 1871 Census shows the household at Shepperton had reduced to Cooper, his two youngest sons (neither of whom married), a cook, parlourmaid and housemaid. By this time Cooper had perhaps made deep inroads into the inheritance which his mother had left him over twenty years before. Although Charlotte's father had survived his daughter by six years, the lands in Canada originally belonging to Colonel John By were passed to her children shortly after her death relieving, in part, Cooper's responsibility of providing for them.

On the 21st of August 1877 Cooper died. Kennett, then a major in the 60th Rifles, was present at his death. He was buried beside Charlotte at Kensall Green and a brass wall plate was erected by his children in St Nicholas's Church, Shepperton.

> In loving memory of Charles Cooper Henderson Esq.,
> born at Chertsey June 14th 1803, died at Halliford
> August 21st 1877, and of Charlotte his wife, born in
> London March 10th 1813, died in London May 31st 1858.

The tablet displays a coat-of-arms of Hendersons of Scottish origin.

There is very little to tell us of Cooper's nature but I believe I would not be far wrong if I described it as I found it in the character of his great grand-daughter. Her features are remarkably similar to those seen in Cooper's face in the photograph of him; both display self-confidence, pride and a certain pugnacity. 'We're inclined to be a quarrelsome family,' she said. 'And we don't mind telling people what we think of them!' If one accepts these traits of independence and blends them with words from the obituary notice of his son Major-General Kennett Henderson: 'He was a most kind-hearted and good natured officer, who took the greatest interest in the welfare of the Regiment . . .', we may come as close as we can to knowing Cooper's character. Also, it is not difficult to understand how his life took the turn which it did resulting, by chance, in his becoming the best painter of a coach and team in action.

Cooper's brother John died just over a year later and because he bequeathed many valuable antiquities to his old University, his collection of watercolours to the British Museum and other paintings to the National Gallery, his passing was more noted than that of Cooper Henderson. However, in the September number of *Baily's Magazine* 1877, the following notice could not have better described Cooper's reputation as a painter of the Open Road.

'We saw in the Times, lately, the death of Charles Cooper Henderson, the well-known painter of coaching and road scenes, whose pictures at the late exhibition in Bond Street were the gems of the collection. His loss is to be much regretted. It is not too much to say that what Mr. Apperley's (Nimrod's) pen did for the road was equally well done by Mr. Henderson's brush. For spirit and truth of detail he was unrivalled, and his pictures now will have a double value, and be counted as treasures in every sportsman's house.'

The name of Charles Cooper Henderson was perpetuated after the death of his youngest son in 1913. Henry Cooper Henderson left a legacy for a lifeboat to be purchased and named after his father, and stationed, if possible, at Ramsgate where Henry had mostly lived, or at an important station on the South Coast. On the 9th of September 1933 the *Charles Cooper Henderson*, a 41-foot beach lifeboat, was launched at Dungeness into a heavy sea. While stationed at Dungeness between 1933 and 1957 this lifeboat was launched on 170 occasions saving 63 lives; it was also involved in the evacuation from Dunkirk. While on duty in the relief fleet from 1958 to 1974, 82 lives were saved in 114 launches.

The Henderson Family Tree

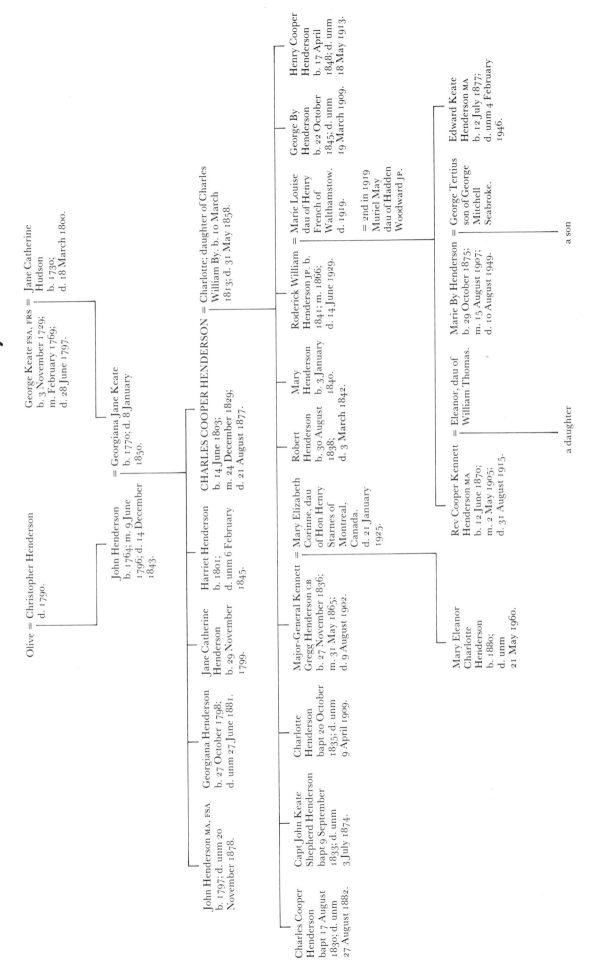

Contemporary Painters
of the Road

Very few artists specialised in road scenes during the coaching era; other sporting painters, preoccupied with horse portraits, racing and the hunting field, occasionally turned to carriages and coaches for inspiration; and many more artists of the period included a phaeton or chariot to provide movement and interest in a landscape. In reviewing the work of Cooper Henderson's contemporaries (using his full life span for this purpose), the landscapists where the coach is incidental to the scene have been discarded, but those who painted vehicles as the subjects of their canvas or watercolour have been included.

The list of specialists is short comprising John Cordrey, the forerunner in style of James Pollard, Henderson and Charles B. Newhouse, the last joining this select group as a makeweight. The early occasional painters are George Stubbs, Jacques-Laurent Agasse, the Frenchmen Louis-Leopold Boilly and Eugene Lami, and the little known Edward Hull whose Francophilia and lively technique have much in common with Cooper Henderson and his work. Others who painted carriages and coaches from time to time were Michael Egerton, the Havells, John Ferneley, Henry Alken, S. J. E. Jones, Edward F. Lambert, John F. Herring and W. J. Shayer. Finally, A. F. de Prades, H. J. Jones and the prolific but not proficient J. C. Maggs brings us to the end of the nineteenth century. This roll call is not intended to be exhaustive (a more comprehensive list is given at page 92) and the many good paintings attributed to those already named, but which are plainly not by them, leaves one with the conclusion that at least one more nineteenth-century artist of the Road has yet to be identified.

Very little is known of John Cordrey (*c*1865–*c*1825) but his naive paintings, usually of mail or stage coaches are instantly recognisable. The coach and four proceed from right to left over a flat turnpike with a wood or a low hill in the background. The destinations are clearly painted on the coach panels as is every feature of the ensemble captured, as it were, by a high-speed camera. There is no attempt to indicate movement beyond the raised knees of the well-matched horses. Cordrey often shows a diminutive female beside the coachman and in more than one painting of coaches a gentleman on the rear seat throws a protective or amorous arm round the shoulders of his small companion, an endearing detail. A milestone conveniently provides the date of the picture and a cheerful sky sheds a uniform light across the canvas. Cordrey's paintings are accurate portraits of the vehicles of his day and a

59 Returning from the Shoot

Oil on canvas, signed with monogram,
13 × 24 inches

A. Ackermann & Son

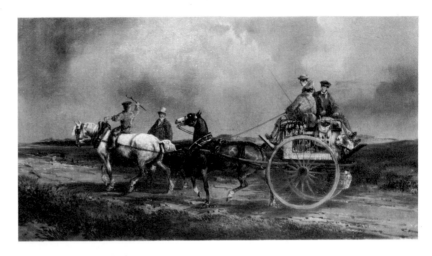

60 Figures in a Jaunting Cart

Oil on canvas, signed
with monogram, 13 × 24 inches

The Fine Art Society

A pair:

Oils on canvas, monograms
on baggage,
12½ × 23½ inches

The Fine Art Society

61 Louth-London Royal Mail on a Cold Morning

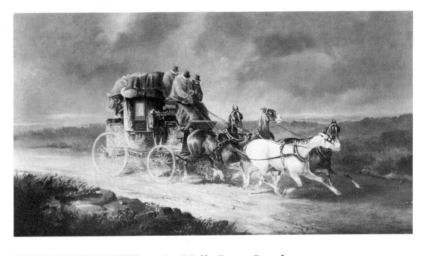

62 Wells-Lynn-London Royal Mail Waking up

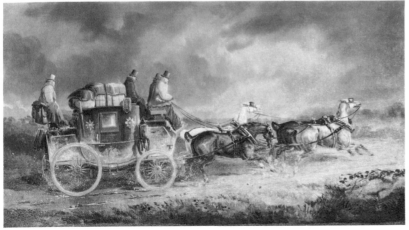

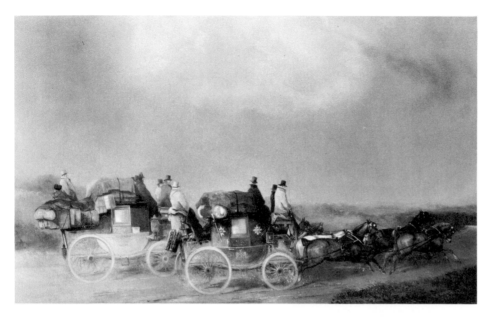

A pair:

Oils on canvas, monograms on baggage, 18 × 30 inches

N. R. Omell

63 **Bath-London Royal Mail Overtaking Messrs. Healey, Lane & Sherman's Bath-Bristol-London Stage Coach**

64 **Early Morning. The Louth-London Royal Mail Meeting Another**

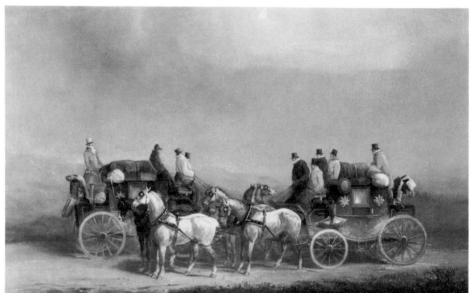

65 **The Rat-Catcher**

Watercolour, signed with monogram, 7 × 5½ inches

British Museum

66 The Exeter-London Coach Meeting Another

Watercolour, signed with Monogram, 8¾ × 10½ inches

Sotheby's

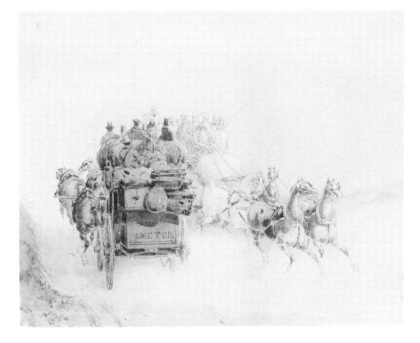

67 French Fishermen

Watercolour, signed with monogram, 4½ × 5½ inches

Private Collection

68 Old Sea Dogs

Watercolour, signed with monogram, 5 × 4 inches

Private Collection

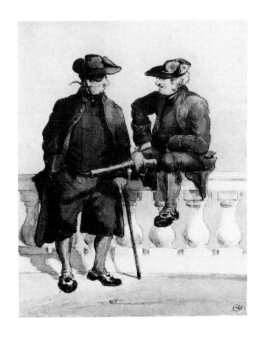

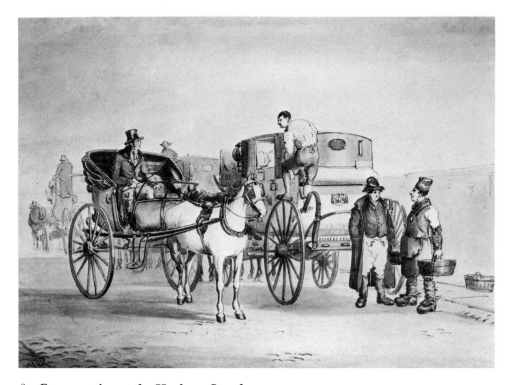

69 Conversation at the Hackney Stand

Watercolour, signed with monogram, 9½ × 13½ inches. *Private Collection*

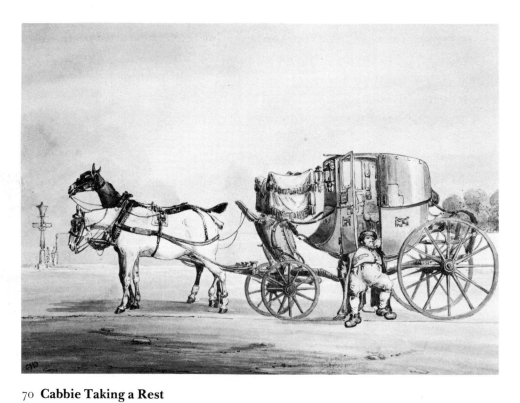

70 Cabbie Taking a Rest

Watercolour, signed with monogram, 9½ × 13½ inches. *Private Collection*

study of them will tell the Road historian nearly all he needs to know of the period.

It is surprising how many of these paintings there are and one wonders for whom they were painted. The immediate thought is that Cordrey was once employed as a coach painter, graduating to embellishing the doors and panels before, perhaps, being commissioned to paint long-vanished inn signs. This was the course taken by a number of aspiring sporting artists but does not explain the existence of his many highly finished canvasses. Cordrey painted a few hunting scenes as well. Their composition is very similar to the work of John Nost Sartorius (1759–1828) and they have the same simple charm as his coaching pictures. He did not exhibit and his work does not appear to have been engraved. This points to him being unappreciated in his lifetime. His work is recognised now, not least because many aspects of it are reflected in the paintings of the far better known James Pollard.

The work of James Pollard (1792–1867) has some of the naivety of Cordrey, but his coaching pictures are full of incident and the countryside or townscape background can often be identified which adds interest to the whole decorative scene. Mr N. C. Selway has written extensively about Pollard and it would be superfluous to rehearse his life or describe his work in detail except in comparison with Cooper Henderson.

From a quite different background to Henderson, James Pollard, the son of the print publisher Robert Pollard, started by painting in watercolour, engraving some of his early coaching scenes himself but with Robert Havell Snr responsible for many others. It was not until 1820 that he turned to oils. He received a commission through the print publisher Edward Orme to paint an inn sign showing a mail. Basing his picture on an earlier watercolour, the result was admired by others who then commissioned him to make copies, in turn leading to twenty years of painting coaching pictures of dazzling quality and value to the topographical historian. He was also prolific in other sporting fields, far more so than Cooper Henderson. It could be said that Pollard had ten years' start on Henderson and I am sure that the latter must have seen and admired some of his work before his marriage and temporary exile to Bracknell. He would have noted the well-painted coaches and their spruce passengers, also the rather 'wooden' teams reminiscent of Cordrey's work. It was in this last facet that Henderson was so much more successful as all admirers of Pollard would readily admit. It is unlikely that there was any rivalry between the two artists in their lifetimes. Neither exhibited many paintings nor, perhaps, had they any need to advertise; each found ready outlets for their work. It is a coincidence that both painted in oils for only twenty years: Cooper Henderson from 1830 to 1850 and Pollard from 1820 until 1840 when the loss of his wife and youngest daughter brought his painting career to an almost complete halt. Today the work of both artists is much appreciated as it should be, only the criteria for this admiration is different.

Charles B. Newhouse (c1805–c1877) is best known as the originator of two large sets of aquatints engraved by Richard Gilson Reeve (1803–1889). The eighteen plates of 'Scenes on the Road' were published by Thomas McLean in 1834. The second set of sixteen engravings was first published (on grey paper) by John Watson in 1835 with the title: 'Incidents in Travelling'. These prints were re-issued on white paper in 1845 by Fores called 'The

Roadster's Album'. The original watercolours are of vivid and usually anecdotal scenes of road travel when coaching was enjoying its brief golden age. As a watercolourist he made little impact in his day and apart from also painting a few military subjects he was not a well-known artist. However, like Cordrey, Pollard and Henderson, his work provides a valuable contemporary insight of the Open Road.

The sheer elegance of the painting of phaetons by George Stubbs (1724–1806) is more than enough reason to make him a contemporary of Cooper Henderson and to include his name with the occasional coach painters. Stubbs's phaetons were the first of a large family of such vehicles. Hugh McCausland writes that the name phaeton was first applied to a carriage in 1788, although what have been retrospectively called highflyers embracing the perch and crane-neck phaetons (describing features of their construction) were painted by Stubbs a few years earlier. Basil Taylor dates the (crane-neck) 'Phaeton with a Pair of Cream Ponies in Charge of a Stable-Lad' in the Mellon Collection as painted between 1780 and 1785, and the painting of a 'Lady and Gentleman in a Phaeton' in the National Gallery is dated 1787. The most interesting vehicle painted by Stubbs is in his picture of 'The Prince of Wales's Phaeton', dated 1793. The principle subjects of this well known painting in the Royal Collection at Windsor Castle are the Prince's state coachman, the portly Thomas, and a pair of black horses, but it is the anatomy of the phaeton with its dished wheels and embroidered cushions which is spectacular. By painting the elegant lines of these carriages, Stubbs may have encouraged some of those who followed to paint coaches.

Jacques-Laurent Agasse (1767–1849) was predominantly an animal artist but he painted a few pictures of carts, mails and coaches as well as stage waggons, some of which were engraved in the 1820s. He often employed the unusual head-on viewpoint, slightly elevated as though he was standing on a bridge under which the vehicle was about to pass. This demanded careful draughtsmanship in foreshortening without destroying the movement which can most easily be portrayed from the side view. Cooper Henderson rarely painted a fully head-on coach in oils although he was ready to attempt this in watercolour. Agasse was partly successful, and it would be interesting to know why he painted coaches at all since they were well outside his normal range of subjects. One painting (also engraved) is of particular interest to the student of postal history. This shows a guard being driven in his special cart through Temple Bar in London to join his mail. The interest not only lies in the guard's uniform but also in the functional vehicle in which he travels. Mail carts appear in some of Pollard's large and busy scenes and, in a different form, with royal cipher, in Cooper's; 'The Old Service' (Plate 25). While many of the mails started from the old General Post Office in Lombard Street there was not room for them all at the launching of the evening mails; others started from various points in London as can be seen in Cooper's later painting where the guards with their bags of letters join their mails in Piccadilly by means of these Post Office carts.

'L'Arrivee d'une Diligence dans la Cour des Messageries', now in the Louvre, was painted by Louis-Leopold Boilly (1761–1845) in 1803. Cooper Henderson may have seen this fine work during one of his visits to France. The picture is full of interest across the whole canvas, a compositional scheme which Pollard and to a lesser extent Henderson employed.

The coach is important, but there is much to admire in examining each group of figures or animals, and the accurate portrayal of the architecture of the square is no less a part of many of Pollard's paintings and a few of Cooper Henderson's. Although on the periphery of coaching painters like Theodore Gericault (1791–1824) and Eugene Lami (1800–1890), Boilly may have influenced Cooper Henderson who loved France and was inspired by the work of some of her artists.

The watercolours of Edward Hull (fl. 1820–1837) show a remarkable similarity to Cooper's early subjects and drawings, and his interest in the French Road. Like Cordrey, little is known about Hull at present except that he was exhibiting at the Royal Academy in 1827 and the Royal Society of British Artists from 1827 to 1830 (and possibly in 1849) from an address in North Brixton.[1] The subjects shown include: 'Halt of a Baggage Waggon'; 'Le Relays'; 'Place de Petites Voitures'; and 'The Departure', all watercolours. His small drawings have an enviable lightness of touch but at the same time are vigorous and full of movement. His horses can be too long-legged but are still convincing as are his figures of coachmen, ostlers and others connected with travel in England and on the Continent. He used gum-arabic to deepen shading in his larger watercolours which are less successful. He was also a lithographer and a rare set of four small coaching prints in this medium is delightful. Edward Hull was older than Henderson and possibly the last of the coaching artists who might have suggested the field in which he was to specialise.

Next come the occasional painters of coaches among Cooper Henderson's contemporaries although the first, Michael Egerton (fl. 1821–1828), did not paint much else but carriages. It may be presumed from his work signed: 'Drawn by M. E. Esqr.' that he was an amateur; he is known only by the aquatints which George Hunt engraved from his watercolours. As well as mails and coaches he illustrated a number of other carriages such as the barouche, curricle and park phaeton (a development of the phaetons painted by Stubbs). All were drawn with a spidery elegance and he populated his pictures with dandies and filled the carriages with pretty young ladies. There is humour and impudence in what he drew reinforcing the assumption that he was not a serious artist having to earn his living by painting. Robert Havell Snr (1769–1832) and Jnr (1793–1878) painted a few coaching scenes and engraved many more after the work of other artists. Before moving to London in 1801, Robert Havell Snr was living in Reading, probably one of five brothers whose father taught drawing and owned a small shop. Many of the coaching paintings by the two Roberts were connected with that town and were engraved between 1818 and 1834. Their style is that of James Pollard and an example of their similarity is the scene of 'The Lioness Attacking the Horse of the Exeter Mail Coach', a night-time incident which took place on the 20th of October 1816 at Winterslow on the edge of Salisbury Plain. An oil painting of this event in the Sir Abe Bailey Collection of British Sporting Paintings and Drawings in the South African National Gallery was previously attributed to Pollard but is now thought to have been painted by Robert Havell Snr after his own engraving of Pollard's watercolour. The curiously parallel careers of the Havells and Pollards as publishers, artists and

[1] He should not be confused with Edward Hull (1822–c1890) of Bedford, a watercolour landscapist and brother of the artist William Hull (1820–1880).

engravers made a significant contribution in popularising the genre of sporting and coaching paintings and engravings at the beginning of the nineteenth century. Another Havell, George, painted the picture for a familiar aquatint: 'The Blenheim Leaving the Star Hotel, Oxford' which was engraved by Frederick James Havell (1801–1841). This is a static but interesting scene of a coach loading up outside the hotel on much the same lines as Cooper Henderson's 'Age' at Brighton, in reverse. Almost exactly the same composition as The Blenheim was used by Bradford Rudge in his lithograph of 'The Bedford Times' outside The Swan at Bedford. This print records the last journey of the coach to London on the Saturday after the opening of the Bedford branch of the London and North Western Railway on the 21st of November, 1846. This coach had been running for twenty-one years.

John Ferneley (1782–1860) painted carriages as a setting for human and equine portraits. They are therefore usually stationary and he did not paint Road scenes. However, his cabriolets and phaetons have a historical interest and the accuracy of the detail shows a thorough understanding of their construction and uses. Henry Alken Snr (1785–1851) painted pictures to satisfy his publishers and, in consequence, some of his coaching scenes in oils were executed hurriedly to the extent of untidiness; his watercolours are very much finer and the carriages and horses have a panache which Cooper Henderson could not match. Samuel John Egbert Jones (fl. 1820–1845) painted coaches on many occasions. They moved through finely painted landscapes or London streets such as The Elephant and Castle, Newington or The Post Office, Lombard Street with the usual attendant bustle, activity and air of excitement. Like Agasse, he sometimes painted his coach and team head-on with all the difficulties which this angle presented not completely mastered. Like Jones, Edward F. Lambert (fl. 1823–1846) was a London based artist occasionally painting the sporting scene. His unsigned picture of the Brighton Coach at the Bull and Mouth in St Martin's-le-Grand is outstanding and depicts the 'Age' coach. The aquatint engraved by G. and C. Hunt in 1829 after this painting is dedicated by the publisher to Henry Stevenson the amateur coachman whom Henderson drew with his Coach at Brighton. Lambert may have been the author of more coaching and sporting paintings but his main preoccupation was in illustrating historical events and taking his themes from literature.

John Frederick Herring (1795–1865) and William Joseph Shayer (1811–1892) were near contemporaries of Cooper Henderson. Both spent some time as coachmen and from these experiences were able to paint coaching scenes with an accuracy and understanding which Cooper had to learn from observation, and perhaps some amateur practise in handling the reins. However, neither Herring nor Shayer managed to convey the speed of a coach or carriage with quite the same zest and *élan* as Cooper Henderson. Shayer's paintings of coaches are sometimes a little prosaic but come closest to Henderson in producing the atmosphere of Road travel in all weathers.

Of the other artists already mentioned only Alfred de Prades (fl. 1844–1884) shows skill in a manner close to Shayer, and the work of H. J. Jones is in a similar vein. Lastly, John Charles Maggs (1819–1896) was immensely popular in his day, prolific to the point of being repetitious and employing a factory of assistants in Bath to satisfy an apparently insatiable clientele (which included Queen Victoria) wanting coaching pictures. As might be ex-

pected, many of the results were disappointing and to compare his work with that of Cooper Henderson requires more generosity than I can find.

One other painter who should be recorded is John Sinclair. He was a very fine copyist employed at one time by Messrs Fores. He produced paintings of the Road in the styles of a number of artists, but mainly that of James Pollard, achieving the same decorative effect. He rarely signed these paintings and where a doubtful signature now appears it was probably added by an unscrupulous dealer or a collector who did not want to admit that he had been taken in by a copy. Whether Sinclair copied any of Cooper Henderson's work is not clear but there are a number of pictures which could be by him and which are plainly not by Henderson. The difference between the 'right' and 'wrong' picture is in the painting of horses; a variance which is more difficult to establish between a right and wrong painting thought to be by James Pollard.

Cooper Henderson was a gentleman-artist who went his own way having assimilated some aspects of the work of early English and, particularly, French painters of coaches and horses. Short of accusing him of being blinkered to the efforts of his close contemporaries he took little notice of their work. On the other hand, if he was alive today he would surely be pleased to have his name associated with the specialists of the Road, and probably considered himself the best of the select few!

British and French Artists Painting Carriages and Coaches in the 18th and 19th Centuries

Where fl. (floreat) precedes the first date it has been assumed that the artist was 20 years old in that year.

George Stubbs ARA 1724–1806

Thomas Gooch c1750–c1820

George Garrard ARA 1760–1826

Louis-Leopold Boilly 1761–1845

John Cordrey c1765–c1825

Jacques-Laurent Agasse 1767–1849

Robert Havell Snr 1769–1832

T. C. Cooper fl.1790–1820

Sir John Dean Paul 1775–1852

Francis Calcraft Turner 1782–1846

John Ferneley 1782–1860

Henry Thomas Alken (Henry Alken Snr) 1785–1851

Edwin Cooper 1785–1833

Gabriel Shire Tregear fl.1810–1835

Theodore Gericault 1791–1824

James Pollard 1792–1867

Robert Havell Jnr 1793–1878

John Frederick Herring 1795–1865

Charles Hancock 1795–1868

Eugene Lami 1800–1890

Edward Hull fl.1820–1837

Samuel John Egbert Jones fl.1820–1845

Robert Richard Scanlon 1801–c1870

Michael Egerton fl.1821–1828

Charles Cooper Henderson 1803–1877

Charles Hunt 1803–1877

Edward F. Lambert fl.1823–1846

Charles B. Newhouse c1805–c1877

George Havell fl.1826–d.1840

John Dalby fl.1826–1853

Samuel Henry Alken (Henry Alken Jnr) 1810–1894

James Barry fl.1830–1850

William Joseph Shayer 1811–1892

Hablot Knight Brown ('Phiz') 1815–1896

John Charles Maggs 1819–1896

Michael Angelo Hayes 1820–1877

Anson Ambrose Martin fl.1840–1861

Alfred F. de Prades fl.1844–1884

Canon G. R. Winter 1826–1895

H. J. Jones fl.1850–1875

John Sturgess fl.1864–1884

George Wright 1860–1942

Lynwood Palmer 1868–1941

Cecil Aldin 1870–1935

Gilbert Scott Wright 1880–1958

Works by Cooper Henderson in Public Galleries and Published Collections

ENGLAND

The Tate Gallery, Millbank

Changing Horses to a Post-Chaise outside the 'George' Posting House
Oil on canvas, signed with monogram, 21 × 30 inches (53.5 × 76 cms)
Presented by Mr Paul Mellon KBE through the British Sporting Art Trust.

August the 12th
Oil on canvas, signed with monogram, 13½ × 24½ inches (34.3 × 62.2 cms)
Bequest of Mrs F. Ambrose Clark from the Collection of F. Ambrose Clark through the British Sporting Art Trust.

Snow Bound
Oil on canvas, signed with monogram, 18 × 29 inches (45.7 × 73.6 cms)
Bequest of Mrs F. Ambrose Clark from the Collection of F. Ambrose Clark through the British Sporting Art Trust.

In the Collection of the British Sporting Art Trust

Coaching Abroad
Oil on canvas, signed with monogram, 16½ × 20½ inches (42 × 52 cms)
Loaned to the British Sporting Art Trust by V. Morley Lawson Esq.

Coaching in England
Oil on canvas, signed with monogram, 16½ × 20½ inches (42 × 52 cms)
Loaned to the British Sporting Art Trust by V. Morley Lawson Esq.

Victoria and Albert Museum

An Old Carriage
Watercolour, signed with monogram, 9 × 13 inches (22.9 × 33 cms)
Prov. Collection of Sir Walter Gilbey, Bart.

Sketches (6) of Men and Draught-Horses
Pen and ink and watercolour, signed with monogram, average size 2¾ × 4½ inches (5.6 × 11.4 cms)
Bequeathed by H. H. Harrod.

A Cavalry Engagement in a Snow-Storm
Watercolour, signed with monogram, 5 × 11 inches (12.7 × 28 cms)
Bequeathed by H. H. Harrod.

The Museum of London, London Wall, London

Street Sellers in Drury Lane
Watercolour heightened with white, signed with monogram, 8¼ × 8½ inches (20.7 × 21.6 cms)
Prov. Purchased from T. Spencer

A Rat Catcher
Watercolour with bodycolour on blue paper, signed with monogram, 7½ × 5¼ inches (19 × 13.4 cms)
Prov. Purchased from Abbott & Holder.

A Coal Tar Painter
Watercolour with bodycolour on blue paper, signed with monogram, 7¼ × 5¼ inches (18.4 × 13.4 cms)
Prov. Purchased from Abbott & Holder.

A Hot Codlin's Seller
Watercolour with bodycolour on blue paper, signed with monogram, 7 × 5¼ inches (17.8 × 13.4 cms)
Prov. Purchased from Abbott & Holder.

A Victorian Dustcart
Watercolour with bodycolour, signed with monogram, 8 × 11¾ inches (20.4 × 29.7 cms)
Prov. Purchased from Frank T. Sabin.

Ferens Art Gallery, Hull

Hull and London Royal Mail
Oil on canvas, signed with monogram, 13 × 24 inches (33 × 61 cms)
Prov. Purchased at the Harewood House Sale, 29 June 1951.

Leeds and London Royal Mail
Oil on canvas, signed with monogram, 13 × 24 inches (33 × 61 cms)
Prov. Purchased at the Harewood House Sale, 29 June 1951.

Folkestone Museum

In the Masters Collection

French Postillion
Pencil, signed C.H., 6½ × 4 inches (16.3 × 10.2 cms)

French Postillion, his boots in 1824
Pencil, signed C.H., 6½ × 4 inches (16.3 × 10.2 cms)

Postillion Posting with Two Horses
Pencil, 4 × 6½ inches (10.2 × 16.3 cms)

A Coal Porter
Brown ink and watercolour on brown paper, signed with monogram, 8½ × 5¼ inches (21.5 × 13.4 cms)

The Victoria Art Gallery, Bath

Bristol and London Stage Coach
Oil on canvas, signed with monogram, 12½ × 23¼ inches (31.7 × 59.8 cms)
Presented by the National Art Collections Fund, from the estate of Ernest Cook of Bath.

Leeds and London Royal Mail
Oil on canvas, signed with monogram, 12½ × 23¼ inches (31.7 × 59.8 cms)
Presented by the National Art Collections Fund, from the estate of Ernest Cook of Bath.

UNITED STATES OF AMERICA

Paul Mellon Collection, Upperville, Virginia

A set of four:

Hull and London Royal Mail Outside a Country Blacksmith's Shop
Birmingham and London Royal Mail
Dover and London Royal Mail
Wells and London Royal Mail by Night
Oils on canvas, signed with monogram, each 12¾ × 24 inches (32.5 × 61 cms)
Prov. Wildenstein, New York, 1954.
Exhibited London, Loan Exhibition at Viscount Allendale's, Sporting Paintings, 1931.

A pair:

The 'Quicksilver' Devonport and London Royal Mail About to Start with a New Team
Louth and London Royal Mail Progressing at Speed
Oils on canvas, signed with monogram, each 12¾ × 20¾ inches (32.5 × 52.7 cms)
Prov. Ackermann 1962.

A Scene on the Road in France
Oil on canvas, signed with monogram, 8½ × 12 inches (21.5 × 30.5 cms)
Prov. Sabin Galleries, 1962 (as 'Travelling Companions').

Unloading the Luggage from the Exeter Coach
Watercolour, 12 × 18½ inches (30.5 × 46.7 cms)
Prov. Spink 1967.

A Travelling Chariot and Pair
Watercolour, signed with monogram, 5¾ × 8½
inches (14.5 × 21.5 cms)
Prov. Colnaghi 1961.

**A Post-Boy Riding Back with his Pair of
Horses**
Pen and ink, signed with monogram, 5¼ × 7¼
inches (13.4 × 18.5 cms)
Prov. Colnaghi 1961.

**Interior of a Post-House Stable, with Horses
Feeding**
Watercolour, 7¼ × 17 inches (18.7 × 43.2 cms)
Prov. Sabin Galleries 1962.

A French Diligence of 1830
Watercolour on grey paper, signed with
monogram, 7½ × 15 inches (19 × 38 cms)
Prov. Colnaghi 1961.

**Studies of a Diligence, a Travelling Coach,
Horses and Figures**
Watercolour, 7 × 10½ inches (18.7 × 26.6 cms)
Prov. Sabin Galleries.

English Travellers in Italy
Watercolour, 9½ × 12½ inches (24 × 34.2 cms)
Prov. Ackermann 1969.

A Hay Waggon Drawn by Four Horses
Pen, ink and watercolour, 6¼ × 10½ inches
(16 × 27 cms)
Prov. Martin Hardie 1961.

SOUTH AFRICA

The Sir Abe Bailey Collection of British
Sporting Paintings and Drawings
at the South African National Gallery,
Cape Town.

Fox Hunting – a set of four:

The Meet
Setting Off
Taking a Stream
Full Cry
Oils on canvas, signed with monogram, each 13½
× 24 inches (34 × 61.5 cms)

**A Stage Coach Fording a Stream in a
Snowstorm**
Oil on board, 10¼ × 18¼ inches
(26 × 46 cms)

**Cambridge and London Royal Mail on a
Muddy Road**
Watercolour heightened with white,
18¼ × 27¾ inches (46 × 70.5 cms)

Leeds and London Royal Mail on a Wet Road
Watercolour heightened with white,
15¾ × 27¼ inches (40 × 69.5 cms)
(This and the previous watercolour seem unusually
large for Cooper Henderson)

Stages Coaches Racing on the Open Road
Watercolour heightened with white, signed with
monogram, 10½ × 14½ inches (27 × 37 cms)

Engravings by and after the Work of Cooper Henderson

1827

Three Etchings:
(1) **Post-Boy**
(2) **Mail Coachman**
(3) **Ostler**
Engraved by C. C. Henderson
Published by S. Pearse, 31 Conduit Street,
Jany 1, 1827.
Etchings, plate 6 × 4 inches (15.2 × 10.2 cms)
(2) has no publication line.

Place de Fiacres
C. C. Henderson delt. Printed by C. Hullmandell.
Published by S. Pearse, 31 Conduit Street, London
1827.
Lithograph coloured by hand, subject 12¼ × 19¾
inches (31.1 × 50.2 cms)
A crude but jolly scene of a coach, cabriolet and
three figures standing by a building with various
signs in French.

1830

A French Diligence
Engraved by S. G. Hughes
London, Published 1830 by R. Ackermann,
96 Strand.
Aquatint coloured by hand, subject 10½ × 17
inches (26.7 × 44 cms)

1834

A pair:
English Post-Boys
French Postilions
Engraved by J. Harris (?)
London, Published 1834 by R. Ackermann & Co.,
96 Strand.
Aquatints coloured by hand, subject 10 × 15
inches (27.3 × 38 cms), plate 13 × 17¼ inches
(33 × 43.7 cms)

1837

**The Taglioni!!! (The Windsor Coach at Full
Speed)**
Engraved by J. Harris
London, Published Oct 1st, 1837 by
R. Ackermann, at his Eclipse Sporting Gallery,
191 Regent Street.
Aquatint coloured by hand, subject 12¼ × 18
inches (31.1 × 45.8 cms), plate 15¾ × 20½ inches
(40.1 × 52.1 cms)

A pair:
Changing Horses
French Diligence
London, Published Oct 1st, 1837 by
R. Ackermann, at his Eclipse Sporting Gallery,
191 Regent Street.
Aquatints coloured by hand, subject 11 × 15
inches (28 × 38 cms)
Republished by James Sheldon with title:
Sheldon's Coaching Recollections, with two plates
added:
3 **Opposition Coaches**
4 **Halfway (Leeds Coaches)**
London, published by James Sheldon,
31 Ely Place.
Late impressions of these plates have neither the
title Sheldon's Coaching Recollections nor
publication line.

1839

The Turnpike Gate
Engraved by J. Harris
London, Published March 1st, 1839 by
R. Ackermann, at his Eclipse Sporting Gallery,
191 Regent Street.
Aquatint coloured by hand, subject 14¾ × 20½
inches (37.4 × 52.1 cms)

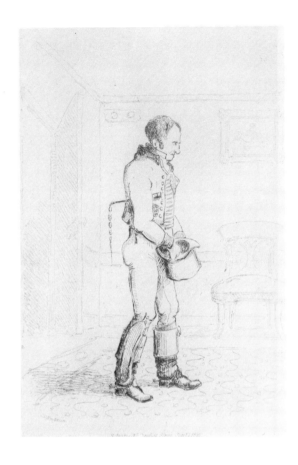

71 Post-Boy

Etching by C. C. Henderson

See page 45

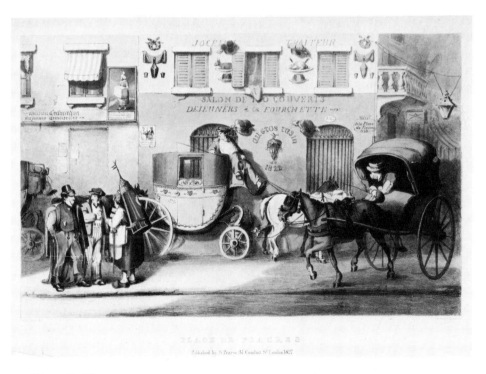

72 Place de Fiacres

C. C. Henderson delt. Lithograph. *British Museum.* See page 45

A pair:

73 **English Post-Boys**

74 **French Postilions**

Aquatints. See page 58

75 The Taglioni!!! (Windsor Coach at Full Speed)

Aquatint. See page 60

76 The Turnpike Gate

Aquatint

Bruce Castle Museum

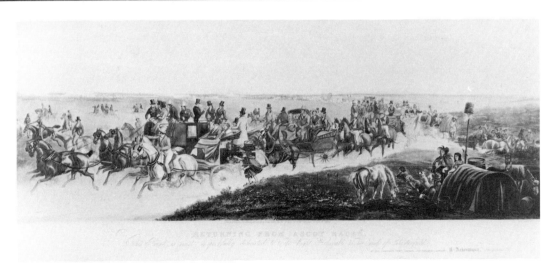

77 Returning from Ascot Races

Aquatint. *Fores Gallery Ltd.*

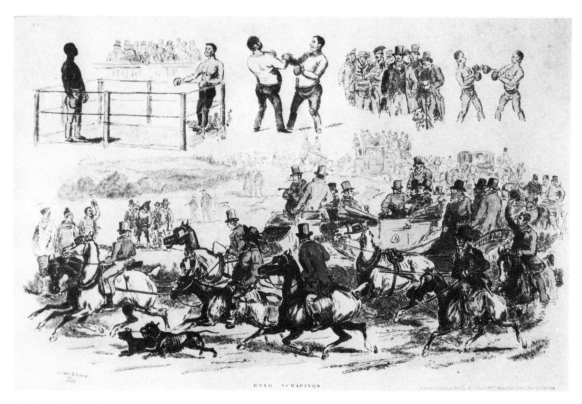

78 **Road Scrapings.** Drawn and etched by C. C. H. Published by N. Calvert. See page 65

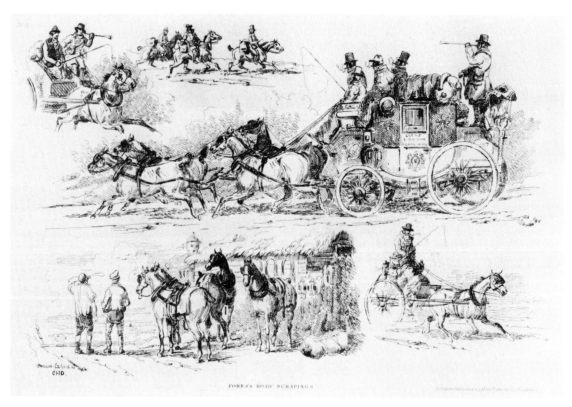

79 **Fores's Road Scrapings.** Drawn and etched by C. C. H. Republished by Messrs. Fores

Returning from Ascot Races
Engraved by E. Duncan
London, Published Sept. 16th, 1839 by
R. Ackermann, at his Eclipse Sporting Gallery,
191 Regent Street.
Dedicated to The Right Honorable The Earl of
Chesterfield.
Aquatint coloured by hand, subject 14¾ × 32
inches (37.4 × 81.2 cms)
Republished by Messrs Fores.

1841–1842

A set of twelve:
Road Scrapings
Drawn and Etched by C·H·Ɔ
London, Published by N. Calvert, No 30,
Wakefield Street, Regent Square.
Etchings, plates 8 × 12 (20.3 × 30.5 cms)
The wrapper, with the above title, depicts a
vignette of roadmenders raking a road surface, a
coach approaching in the distance. The contents
comprise 12 plates of sketches of road scenes, 6 in
England and 6 from the Continent.
Republished by Messrs Fores with title: Fores's
Road Scrapings.
London, Published by Messrs Fores, 41 Piccadilly.

1842

Fox Hunting:
Across Country
Engraved by G. Hunt
London, Published November 6th, 1842 by John
Moore, at his Wholesale Looking Glass & Picture
Manufactory, Nos 1 and 2 Corner of West St,
Upper St Martin's Lane.
Aquatint coloured by hand, subject 11¾ × 17¼
inches (29.8 × 43.8 cms)
This plate is recorded by Captain Frank Siltzer in
The Story of British Sporting Prints, but I have not
seen it.

A pair:
Fores's Road Scenes.
1 **Going to a Fair**
2 **Going to a Fair**
Both: From a Picture in the possession of Francis
Leigh Esqr.
Engraved by J. Harris

London, Published December 1st, 1842 by Messrs
Fores, at their Sporting and Fine Print Repository
and Frame Manufactory, 41 Piccadilly, Corner of
Sackville St.
Aquatints coloured by hand, subject 9 × 23¾
inches (22.9 × 60.2 cms)
Plate 1 is of Hunters and Hacks being led on the
road; Plate 2 is of Farm Horses.

1842–46, 1883

A series of seven:
Fores's Coaching Recollections.
 I **Changing Horses** (From a Picture in the
 possession of Lord Macdonald)
 II **All Right** (From a Picture in the possession
 of C. C. Henderson Esqr)
III **Pulling Up to Unskid** (From a Picture in
 the possession of Lord Macdonald)
 IV **Waking Up** (From a Picture in the
 possession of Lord Macdonald)
 V **The Olden Time** (From a Picture in the
 possession of the publishers)
 VI **The Night Team** (From a Picture in the
 possession of the publishers)
VII **A Hunting Morning**

I, II, III and V engraved by J. Harris; IV
engraved by G. Hunt; VI engraved by H. Papprill;
VII engraved by E. Hester and P. Rainger
London, Published, I and II January 1st, 1842; III
and IV January 2nd, 1843; V October 21st, 1846;
VI 1883; VII not dated, by Messrs Fores at their
Sporting and Fine Print Repository and Frame
Manufactory, 41 Piccadilly, Corner of Sackville St.
Aquatints coloured by hand, subject
approximately 17¾ × 27 inches (45.1 × 68.6 cms),
plate approximately 21¾ × 29½ inches (54 × 75
cms); VII, subject 19½ × 26½ inches (49.5 × 67.2
cms)
Some plates were also published by L. Gambart &
Junin, 51 Rue Aumiere, Paris, and Goupil &
Vibert, 15 Boulevard Montmartre, Paris. Depose a
la Direction.
These plates were partly printed in colour.
Fores Gallery Ltd believe Plate VII was published
c1890. They also say that 'A Hunting Morning'
was so obviously not part of the series that in later
years the top title (Fores's Coaching Recollections)
was removed, together with the plate number.

1843–48

A series of six:
Fores's Coaching Incidents.

 I **Knee Deep**
 II **Stuck Fast**
 III **Flooded**
 IV **The Road Versus Rail**
 V **In Time for the Coach**
 VI **Late for the Mail**

All: From a Picture by C. C. Henderson
I and III–VI engraved by J. Harris; II engraved by E. Duncan
London, Published, I and II November 1st, 1843; III and IV June 12th, 1845; V and VI January 10th, 1848, by Messrs Fores, at their Sporting & Fine Print Repository and Frame Manufactory, 41 Piccadilly, Corner of Sackville St.
Aquatints coloured by hand, subject 12¾ × 23¼ inches (32.4 × 59 cms), plate 16½ × 26¼ inches (42 × 66.6 cms)
Some plates were also published by L. Gambart & Junin, 51 Rue Aumiere, Paris, and Goupil & Vibert, 15 Boulevard Montmartre, Paris. Depose a la Direction.

1847

A pair:
Fores's Sporting Traps
 I **Going to the Moors**
 II **Going to Cover**
Both: From a Picture by C. C. Henderson Esqr in the possession of the Publishers.
Engraved by J. Harris
London, Published July 12th, 1847, by Messrs Fores, at their Sporting and Fine Print Repository and Frame Manufactory, 41 Piccadilly, Corner of Sackville St.
Aquatints coloured by hand, subject 17¾ × 26½ inches (45.1 × 67.2 cms), plate 21 × 29 inches (53.4 × 73.6 cms)

1873

F. Herbault's Sporting Gallery
Going to the Meet
Engraved by Hunt & Son
Above the title: Published by L. Brall & Sons
Below the title: Published March 15th, 1873, by F. Herbault, 166 Strand.
Aquatint coloured by hand, plate 12¼ × 23½ inches (32.5 × 60 cms)
A tandem carrying three top-hatted gentlemen trotting left to right.

1874

A set of five:
Fores's Coaching Recollections
 1 **Changing Horses**
 2 **All Right**
 3 **Pulling up to un-skid**
 4 **Waking Up**
 5 **The Olden Time**
Engraved by H. Papprill
London, Published January 1st, 1874, by Messrs Fores, 41 Piccadilly.
Aquatints coloured by hand, subject 8 × 12 inches (20 × 30.2 cms), plate 11 × 14½ inches (28.3 × 36.8 cms)
These scenes are small replicas of Plates I–V of 'Fores's Coaching Recollections' published 1842–46. They are detailed plates (typical of the period) with crisp etching and a fine aquatint ground.

Undated

The Park. "Twas post meridian half past four.'
Engraved by C.C.H. Printed by Engelmann Graf Coindet & Co.
London, Published by J. W. Fores, 41 Piccadilly.
Lithograph coloured by hand, subject 11½ × 19 inches (29.2 × 48.3 cms)
This view of Hyde Park by the statue of Achilles is said to include portraits of Mr Fitzroy Stanhope, Lord Algernon St Maur, Mr Fores, a Colonel Bridges and the artist.
The publication line shows 'J. W. Fores', this should be S. W. Fores.

The 'Age'. A Sketch from Castle Square, Brighton.
C. C. Henderson delt. On stone by M. Gauci.
London, Published by S. W. Fores, 41 Piccadilly.
Lithograph coloured by hand, subject 11½ × 19½ inches (29.2 × 49.6 cms)
This busy scene of loading up Henry Stevenson's 'Age' coach contains a portrait of Stevenson (the gentleman coachman) standing by the off wheeler talking to an ostler.
This print is similar in style of title and publication line to The Park and may have been intended to be a Pair with it.

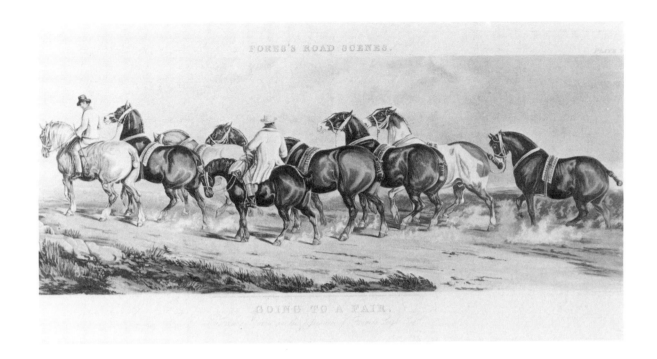

A pair:

Fores's Road Scenes

1 **Going to a Fair** (80)

2 **Going to a Fair** (81)

Aquatints

Fores Gallery Ltd

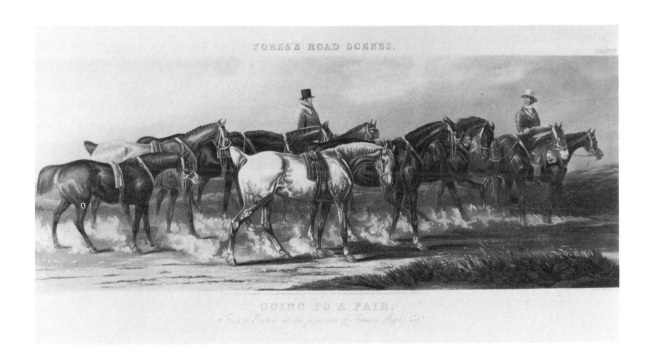

82

83

A series of seven:

Fores's Coaching Recollections

Aquatints

I – III, V and VI *By courtesy of the Post Office*
IV and VII *Fores Gallery Ltd*

84

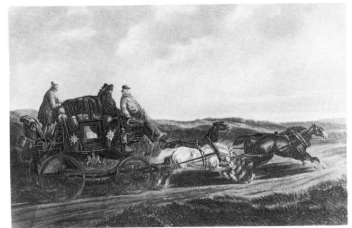

85

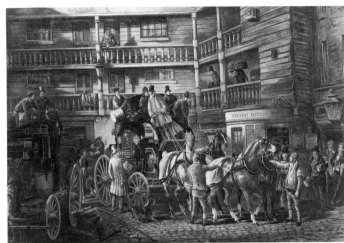

86

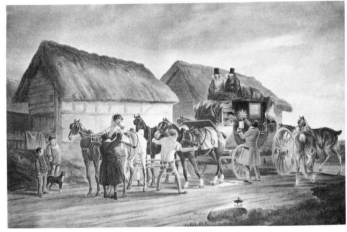

87

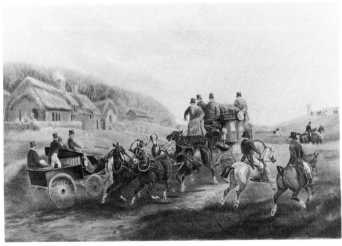

88

On the Road to Gretna

Lithograph coloured by hand, subject 11 × 17½ inches (28 × 44.4 cms)

I have not seen this lithograph with a publication line.

A Post-Chaise and four with two post-boys being pursued along the sands by another coach. The passenger leaning out with a purse to encourage the post-boys.

Royal Fly Van (Pickford & Co., Manchester)

Lithograph coloured by hand, subject 12 × 19 inches (30.6 × 48.3 cms)

I have not seen this lithograph with a publication line.

Pickford's Royal Fly Van is labouring along the road right to left with a team of four heavy horses.

A pair:

Going Easy

Got Hold

London, published by R. Ackermann, at his Eclipse Sporting Gallery, 191 Regent Street.

Lithographs coloured by hand, subject 13 × 24 inches (33 × 61 cms)

Arthur Ackermann & Son believe this pair was first published *c*1840 and continued to be reprinted until the late 1930s.

Engravings after the Work of Cooper Henderson in Sporting Magazines

The history of the nineteenth-century sporting magazines and journals is complicated. The oldest magazine (and the one which lived longest) was the *Sporting Magazine* which was founded in 1792. The *New Sporting Magazine* started publication in 1831 and the *Sportsman* in 1833; six years later, in 1839, the *Sporting Review* was first published.

In 1845 the *Sportsman*, and in the following year the *New Sporting Magazine* were absorbed by the *Sporting Review*, but their titles continued to be published and the content was the same as the *Sporting Review*. In 1848 the *Sporting Magazine* absorbed the *Sporting Review* (and the *New Sporting Magazine* and the *Sportsman*) and thereafter all four titles were published with identical contents to the *Sporting Magazine*. They all ceased publication in 1870.

In 1860, *Baily's Magazine of Sports and Pastimes* started publication to rival the *Sporting Magazine* for ten years until its demise. Baily's stopped publication in 1926.

SPORTING REVIEW

February 1839

The Berkeley Hunt
Engraved by R. Parr
The Cheltenham-London Coach travelling downhill in an extensive landscape.

November 1839

The Earth-Stopper
Engraved by T. A. Prior
An old hunt servant riding his pony, carrying a pick, spade and lantern is accompanied by three terriers on his early morning task.

July 1840

"The Way We Should Go"
Engraved by J. H. Engleheart
The well-laden Emerald-Bristol-London Coach travelling downhill in an extensive landscape.

NEW SPORTING MAGAZINE. New Series

Vol. I. No. VI. June 1841

A Smash in Piccadilly
Engraved by G. Paterson
The wheelers of the Bristol-London Mail are entangled with a fallen grey of a gig in a lamplit scene.

Vol. II. No. VII. July 1841

A Scene on the Roadside
Engraved by H. Guest
Ostlers and a blanketed team waiting at the stable door.

Vol. IV. No. XX. August 1842

French Horses
Engraved by W. B. Scott
Two horses standing by a low wall with two sailors, one mounted.

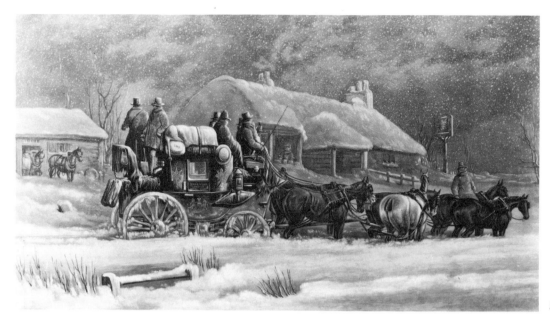

89

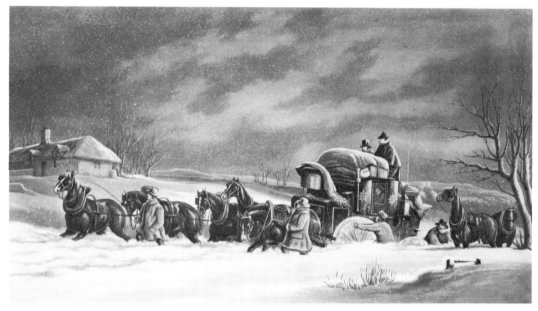

90

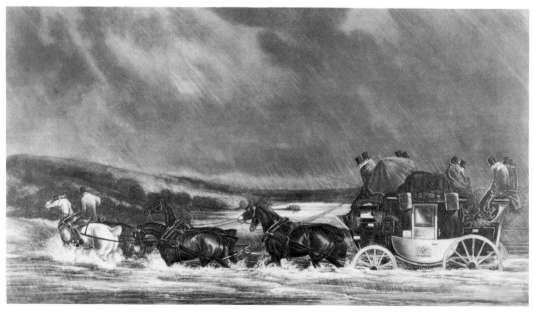

91

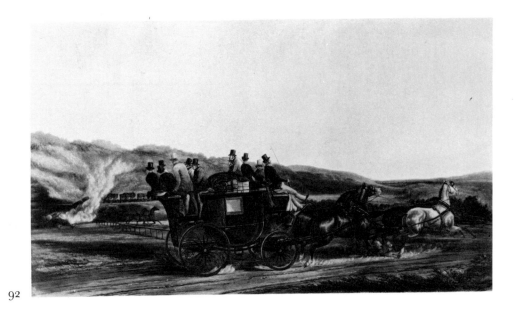

92

A series of six:

Fores's Coaching Incidents

Aquatints

II, III and VI *by Courtesy of the Post Office;* IV *Fores Gallery Ltd;* V *Bruce Castle Museum*

See page 30

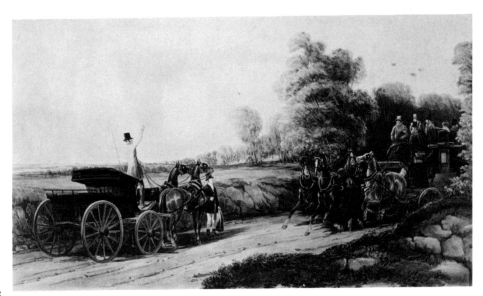

93

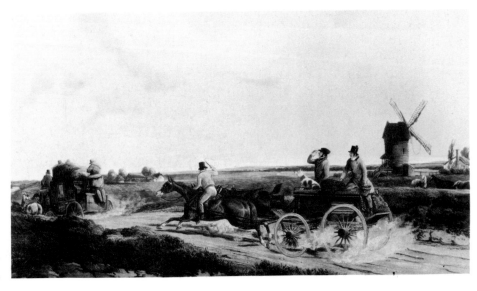

94

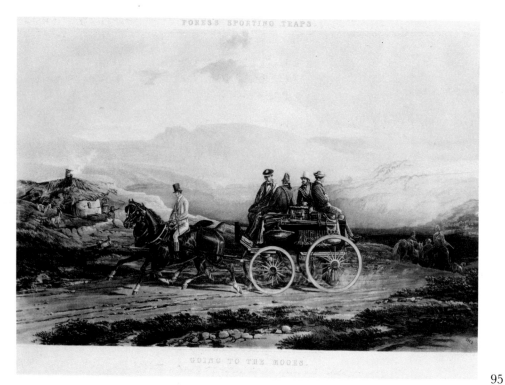

A pair:

Fores's Sporting Traps

I Going to the Moors (95)

II Going to Cover (96)

Aquatints. *Richard Green, London*

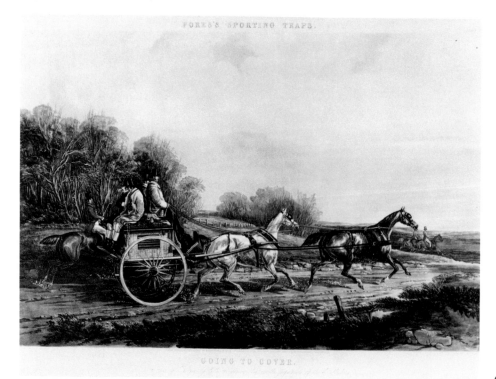

Vol. IV. No. XXIV. December 1842

A Scene on the Great North Road
Engraved by Perren
A Royal Mail climbing a hill pulling to the side to let an oncoming Mail pass.

Vol. V. No. XXVIII. April 1843

The Road to Cover
Engraved by McCabe
Two gentlemen in a mail phaeton with a groom and postillion ridden pair.

SPORTING MAGAZINE (United with The Sportsman, Sporting Review & New Sporting Magazine)

March 1868

Over the Downs
Engraved by E. Hacker
A post-boy returning a pair of posters in a rain storm.

BAILY'S MAGAZINE OF SPORTS AND PASTIMES

Vol. LVII. No. 387. May 1892

Coaching in the Olden Days
Engraved by F. Babbage
A coach on the road approaching right to left, the guard sounding his horn.

Vol. LXIV. No. 427. September 1895

Going to a Fight
Engraved by F. Babbage
A busy scene of coaches and carts "going to a fight". In a subsequent number of the Magazine (November 1895), Cooper Henderson's son, George By Henderson, corrects the title saying it should be "Returning from a Fight".

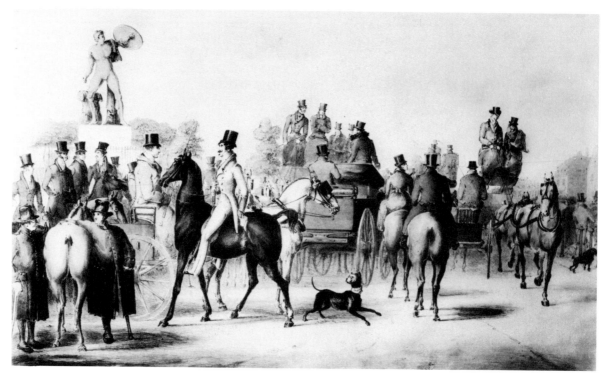

97 **The Park. ''Twas post meridian half past four.'**

C. C. Henderson delt. Lithograph. See page 46

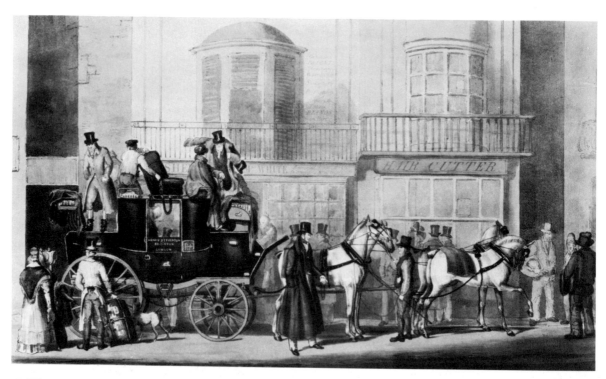

98 **The 'Age'. A Sketch from Castle Square Brighton.**

Lithograph. *Richard Green, London.* See page 45

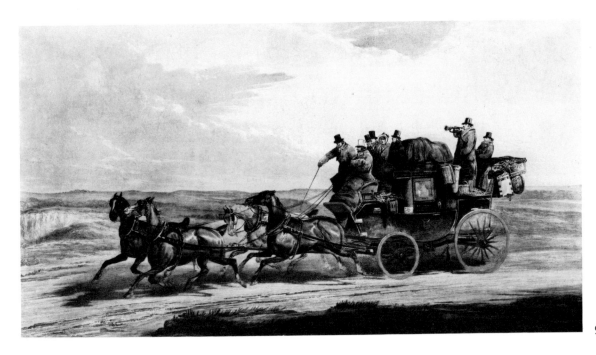

99

A pair:

99 **Going Easy**

100 **Got Hold**

Lithographs. *Richard Green, London*

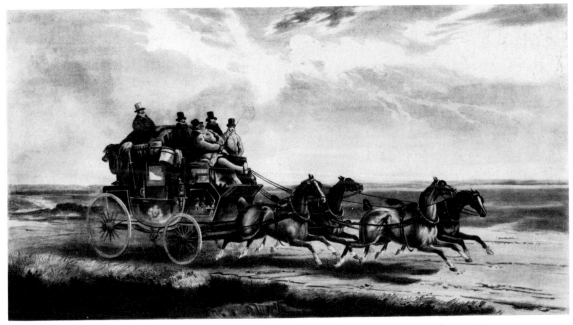

100

A Letter from Cooper Henderson at Winchester to his Mother, dated 12th March 1818

Reproduced by permission of the Warden and Fellows of Winchester College

Dear Mother,

I hope you excuse the shortness of my first letter which I certainly would not have sent if I had been able to have written a better, I forget to tell you that I was very well, I hope you are all well. Pray tell my Father I should have written to him at Bath if I had had time but now if I was to write it is ten to one he would not get it and tell him since I received his I have been happy as the day is long and to continue to please you both and deserve your esteem shall always be my first wish. I hope the Cob will set John up again and give him something to take away his melancholy fits which are very uncomfortable. I promised to give you an account of this place which is a very arduous undertaking and I fear that when the history is finished you will not understand it. 1st. Commoners and College never see one another except in school where we mix in our different classes, and when we go to hills[1] which happens twice a week and then they walk by themselves till we get to the top. We are divided from College by 2 courts well walled. I will now give you an idea of Commoners, in the 1st. place there is a court which my Brother will tell you is a nasty place and it is the only place we have to play in. Then out of this court there is [illegible] into College St. and the gate is opened every day at 12 o clock when [illegible] are allowed to go out for an hour in certain bounds, this Collegers are not allowed. In one corner of the court is Gabell's House and near it a room called Wycombs with toys[2] all round the bedroom above, opposite is a row of buildings where Mrs Bell lives through which as you pass you see a [a very small sketch] hatch the small hole in the door is where milk juggs are passed through but it is so bad I never drink anything for breakfast, now and then I get some tea from the boy who stands at the gate in court, the grating in the window is where the bread is given out, if you turn to your left passing by the hatch you get into Hall which has toys all round it likewise one of which belongs to me and it is a great luxury and everybody is telling me that I am the luckiest fellow they ever knew to get toys in hall the 1st. half year. I will now give you an account of a whole school day, therefore I must begin by the afternoon. A couple of prefects are always in course to keep Hall quiet. After supper I goes round calling toys accordingly we all go to our toys and let down a leaf which makes a table for each [little sketch of toys]. Those boys sharing toys in Wycombs having been forced to run across the yard to get their books set down very much crowded at a long dirty table. We then, I shall only mention the p't I'm in for brevity do our Vulgus ie Latin Verses which as soon as we have done we go to our respective Tutors to get them corrected and signed. We then learn our lesson to say the next morning in school, prayers are then read by the tutor in course, Names are called down by one of the two Prefects and having answered sum away we go to bed. Chapel bells wake us in the morning and we hurry down to Chapel prayers last about ¼ of an hour and then we go back to hall and go into tutor and construe our lesson over to him, we then go into school and we are the 1st. part up at books to Williams, Gabell does not come into school till ½ 8 and our part come out of school with the part above us at nine, the senior part remain till 10 but we are forced to set down quiet in Hall till they come by one of the tutors. The Prefect in full course then calls hatch and the other comes with a stick and drives all towards the door He then calls names and every body in turn takes his sines[3] to table 2 or 3 in a mess feasting on a [illegible] bowls but the generality on eggs some nothing but their sines. Others you see at their toys that do not have messes, some by themselves with at 11 o'clock we go into school again and Williams and Urqhart are only in the school Gabell

thinking it no joke. Our part has then nothing to do but I always learn my afternoon lesson then at 12 o'clock we have leave out and at one dine when names are called over again and after dinner which is most uncomfortable, hustling meal you can imagine, we go into tutor and construe our evening lesson at 2 o'clock go into school and are 1st. up at books again. Gabell does not go in till 3 we come out at 4 and the seniors at 6 when hatch is called again and the same ceremony takes place of delivering the bread and cheese and the Cheese is generally rejected but our family like cheese and I am glad of it. The table then is covered with Coffee, tea, Swipes, private cheeses, barrels of Oysters, meat pies, plates of [illegible] belonging to the different messes but many who sport messes in the morning do not in the evening as it is difficult to get a place on the fire to boil and we are not allowed public boilers in the evening and so on for the next day. I dined the Sunday before last at Captain Gauntlett with 4 Collegers and 1 Commoner. Hound in College is a very clever boy is in the part above me and is under Gabell though he told my Father he was not, he had a letter from Mr [illegible] who desired him to tell me he thought it was a shabby thing my not having called on him now I called with my Father and Brother and left my card so pray let him know it. Tell Mr Prout that Atlee of Wandsworth is here and desires to be remembered to him I was acquainted with him before I came here he has been very kind to me. I find there is a great generality of boys who you know who they belong to an elegant way of expressing myself, I will get a printed roll for you. You will be surprised to hear that I am in the sickroom now or as we say here I am continent and have been so ever since I wrote you last but the long and the short of it is that when I had been here a month I was going to get some bread at hatch and there was a great crowd and one of them I suppose seeing I wanted du pain kindly stood on my toes and contented me I had the skin of my Great toe taken off by the tread and thinking it was not serious I let it go on till the other night finding more blood than usual in my stocking I looked and found it very sore so the doctor saw it and it is getting well I shall be abroad tomorrow or the next day. Continent is a very snugg room with a fire and table and chairs. The 1st. day I was here there were six or seven others, the next day 4 yesterday 1 a very nice fellow, and today I am quite alone and home of course is uppermost in my thoughts and having any of the many things there are, to draw my attention from it. I have just finished dinner which I ate with an exceeding good appetite, with my knee in the fire I question whether you will be able to decypher this but you can employ John the lawyer and put 6d into his pocket for his trouble. I can assure you again I am quite comfortable and happy when not thinking of home which you may be sure I shall never forget. I begg I may be remembered kindly to Mr Prout who I hope is quite well tell him I shall never be able to repay his attention, and thank him sufficiently for this trouble he took with me and my etchings. I beg also to be remembered to your friend [Moxley?] who I suppose has worn his back out in bowing in answer to the applause he nightly receives at the Appollonicon I have received a letter from Gregg in which he seems to know they have behaved wrong and he hopes we shall never fail writing to one another etc. which is better than a quarrel. I beg you will remember me to all my friends for I think it right to cultivate ones acquaintance and all the female acquaintance we possess is but enough for tea and not for [illegible]. How is Colonel Byde. I was under the worst tutor here but he having more than his regular number gave me up to Mr John Williams who is the most clever tutor of the three good luck again you see, so I am sure I ought to complain of nothing. I use my knife and fork at dinner and find them a great luxury. Many thanks for your kind offer of sending anything and shall if it is right but ask Papa 1st get you to send me one of those filtering Coffee Pots that will hold for two in the best shape not to take up [inserted: 'least'] room [a small sketch of a coffee pot] that sort of spout and handle will be best I think because we keep them in our toys and I shall not sport an evening mess I believe coffee is cheaper than tea and so some common coffee and coarse sugar would be very acceptable if convenient to you I have made a grand mistake in folding it up [illegible] so excuse.

[1] St Catherine's Hill outside the town.
[2] A cupboard against the wall with a drop-leaf desk.
[3] The loaves which used to be provided for breakfast for Commoners.

An Article in *Baily's Magazine of Sports and Pastimes*
No 427, September 1895, Volume lxiv

ANIMAL PAINTERS

IV – Charles Cooper Henderson

by Sir Walter Gilbey, Bart

Strange as it may appear, it is none the less true that, owing to the disappearance from the road of the old English coaches and French diligences of little more than fifty years ago, their character and type would scarcely be known to us but for the artists of that day. Many of these artists have, however, left behind them works which will serve to guide us not only as to the build of the vehicles, but also as to the mode of travelling of those days, so different altogether to that of the period in which we live. In this respect the truthful lineations from the brushes of these old artists give us a better idea than could be obtained from the most careful study of contemporary writers on the subject.

The name of Charles Cooper Henderson stands out prominent amongst this class of painters. He was born at the Abbey House, Chertsey, Surrey, on June 14th, 1803, and was the younger son of John Henderson, an amateur artist of more than ordinary merit, by Georgiana Jane, only child of George Keate, FRS, the well-known man of letters, and correspondent of Voltaire. The celebrated Samuel Prout was Henderson's drawing master, acting as teacher also to his brother and sisters.

He was sent to school at Brighton, where he showed considerable artistic talent. Amongst his many drawings at that time was a sketch of a famous character of the town – "The Match Man" – which was so highly thought of that it was published. From Brighton he went to Commoners at Winchester School, and, on leaving there, read for the Bar with Basevi, the special pleader, brother of George Basevi, the architect. Cannop Thirlwall, afterwards Bishop of St Davids, was also a fellow-pupil studying under Basevi. Henderson did not practice at the Bar, but instead spent some time travelling through France and Italy with his father. It was during this visit that he made himself so well acquainted with French horses, their trappings, and the carriages then in general use, as well as with the mode of travelling customary to the early part of this century.

In 1829, at the age of twenty-six, he married Charlotte, daughter of Charles William By, cousin to Lieut.-Col. John By, of the Royal Engineers, who made the Rideau Canal, and who was founder also of By Town, the name afterwards changed to Ottawa when made the capital of Canada in 1858. A considerable portion of the ground on which that town stands was, under Colonel By's will, inherited through their mother by his children.

For some few years Henderson lived at Bracknell, Berks, and later on in London at Lamb's Conduit Street, during which time he depended very much for his income on the works he produced. Later on, however, upon the death of his mother in 1850, he inherited a fortune, which rendered him quite independent of his brush.

Many of Henderson's works were published, amongst them "English Post-boys", "French Postillions", as also "The Turnpike Gate", published by Rudolph Ackermann in the year 1834. "Road Scrapings", the twelve plates which he etched himself, was published by Calvert in 1840; they include several coaching subjects thoroughly English in treatment, as well as Diligence subjects no less characteristically French, and all faithfully portraying the different modes of road travelling in the early part of the present century. The "Temple of Fancy" also was published by Fuller, while others of his paintings were published by Fores. Works from his hands were eagerly sought after by all lovers of sport, and no one ever excelled him in the animation and

spirit which characterised his drawings, as, for instance, "Going to the Fight", "Travelling in France", "The Old Six-horse Diligence", and numerous others.

Henderson exhibited at the Royal Academy, in 1840, "The Edinburgh and Glasgow Mails Parting Company", and again, in the year 1848, a work entitled "The Diligence of 1830". In the *Sporting Review* for the years 1839 and 1840 there will be seen engravings from his works. In Vol. I "The Berkeley Hunt", in Vol. II "The Earth Stopper", and in Vol. IV "The Way we Should Go". There will also be seen in the *Sporting Magazine*, Vol. CLI, for March, 1868, an engraving by E. Hacker, from a picture of Henderson's, "Over the Downs", a pair of post-horses. It is a clever sketch of a pair of post-horses, full of character, with the post-boy's horse fairly startled by the storm, and the grey off-horse dragging, as a hand horse always will drag, at his bridle. In Baily for May, 1892, will be found an engraving, by F. Babbage, from a painting of Henderson's, called "Coaching in the Olden Days".

In 1850 Henderson went to reside at Lower Halliford, on the Thames, and died there on August 21st, 1877. He was buried in the catacombs of Kensal Green, while there is a brass tablet erected to his memory by his children in Shepperton Church. By his wife, who died in 1858, Henderson had seven sons and two daughters, the eldest surviving son being Major-General Kennett Gregg Henderson, CB, commanding the garrison of Alexandria. On going to Halliford, in 1850, Henderson gave up painting for a time, though he resumed his brush in the last few years of his life.

By many now living in London he will be remembered as driving during the season in the park a well-matched old-fashioned pair of roans, in a yellow mail phaeton. In Baily for September, 1877, there is a tribute to his memory, as follows: "We saw in *The Times*, lately, the death of Charles Cooper Henderson, the well-known painter of coaching and road scenes, whose pictures at the late exhibition in Bond Street were the gems of the collection. His loss is to be much regretted. It is not too much to say that what Mr. Apperley's (Nimrod's) pen did for the road was equally well done by Mr. Henderson's brush. For spirit and truth of detail he was unrivalled, and his pictures now will have a double value, and be counted as treasures in every sportsman's house."

Charles Cooper Henderson was more of an amateur, like Henry William Bunbury, than a professional, in not having to depend on the sale of his works. Notwithstanding this, he has left many fine examples of his work both in oil and watercolour.

His elder brother, John Henderson, was the great art collector, who devised by his will the most valuable part of his treasures to the nation.

The following short notice was published in *Baily's Magazine* No 429 November 1895, Vol. LXIV:

Charles Cooper Henderson. – Mr George B. Henderson writes to point out two slight misprints in the biography of his father (Mr Charles Cooper Henderson) which appeared in Baily for September. Firstly, the sketch he made when at school at Brighton should read "The Mousetrap Man", not "The Match Man". Secondly, he says, the title of the engraved picture should evidently be "Returning from the Fight".

Index

(of Pages 17 to 92 inclusive)